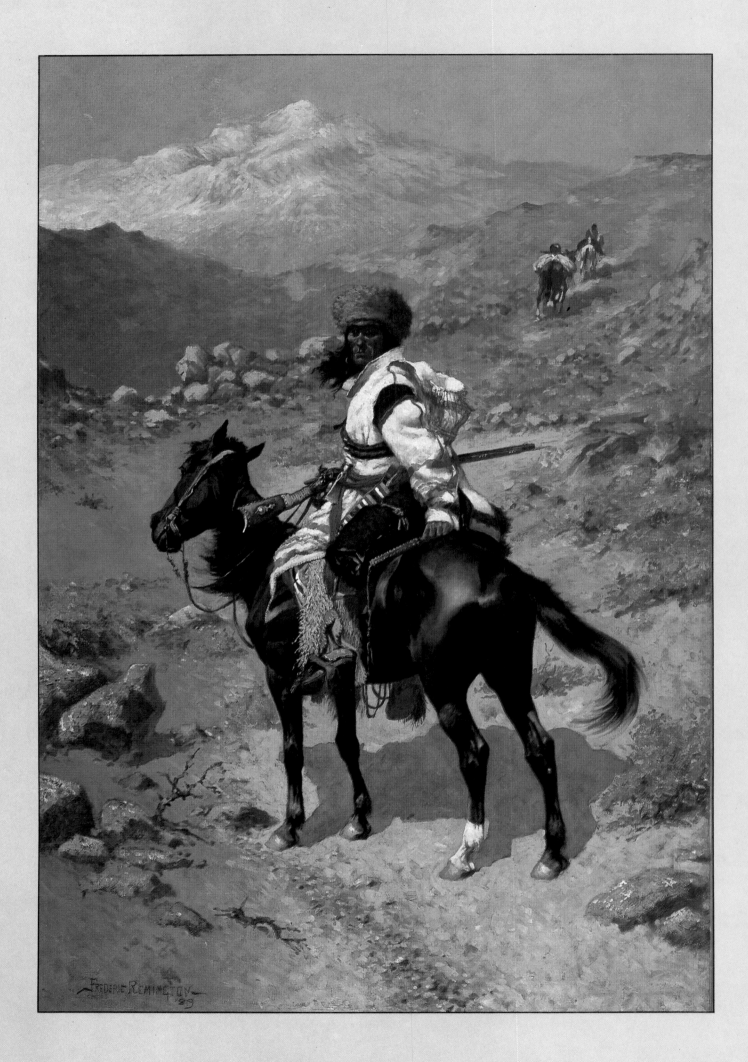

FREDERIC REMINGTON

SOPHIA CRAZE

JG PRESS

Published by World Publications Group, Inc.
455 Somerset Avenue
North Dighton, MA 02764
www.wrldpub.com

ISBN 1-57215-339-3

Printed and bound in China by Leefung-Asco Printers Trading Ltd
1 2 3 4 5 06 05 03 02

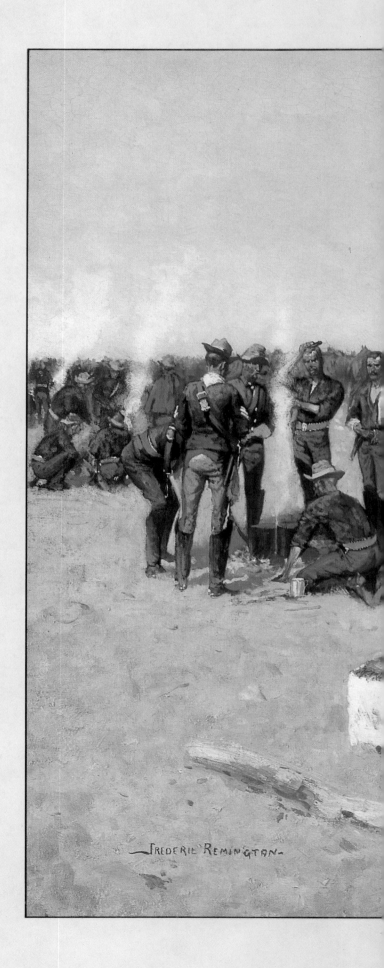

Page 1:
Remington painting *The Indian
Trapper* in 1889.

Page 2:
The Indian Trapper
1889, oil on canvas,
49⅛×34¼in.
*Amon Carter Museum, Fort
Worth, TX*

**Cavalryman's Breakfast on the
Plains**
c.1890, oil on canvas,
22×32¼in.
*Amon Carter Museum, Fort
Worth, TX*

Contents

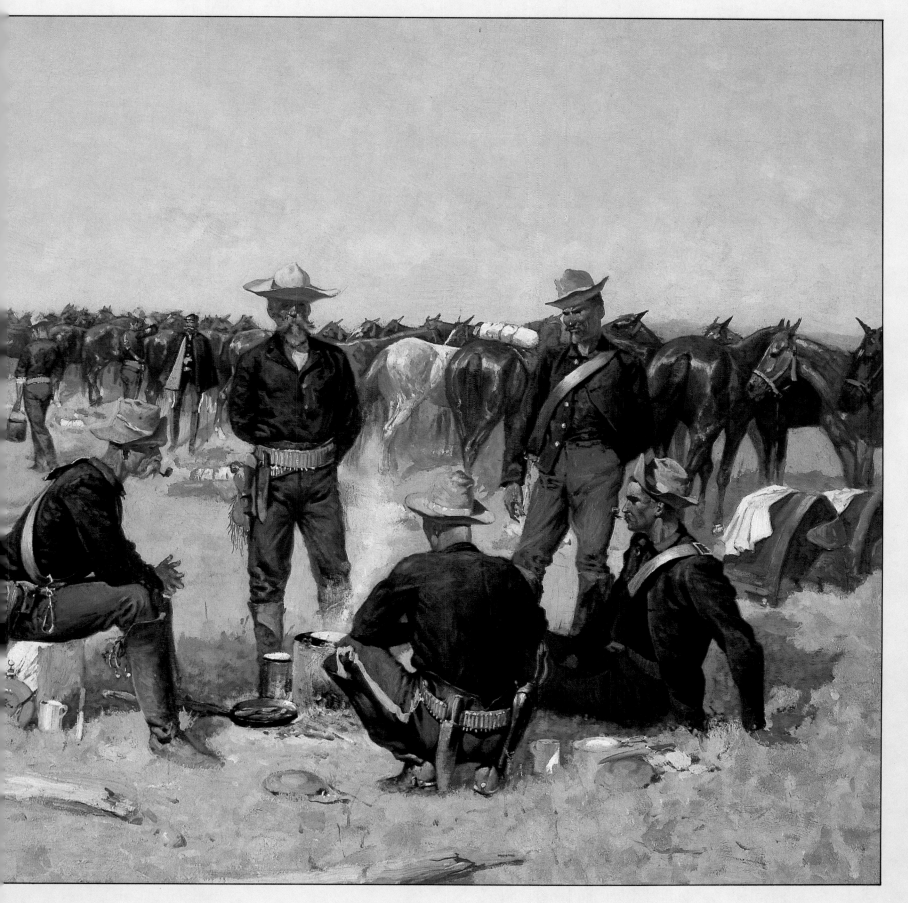

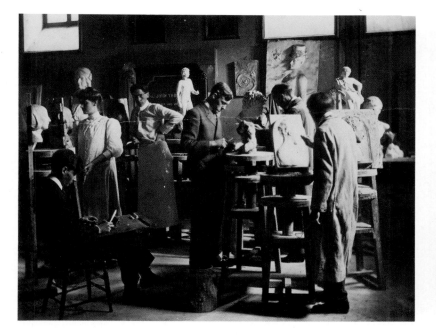

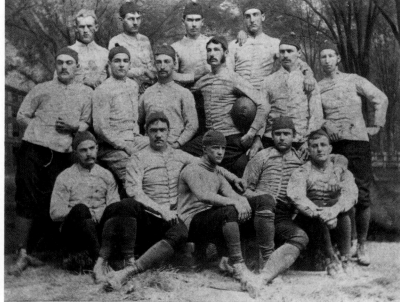

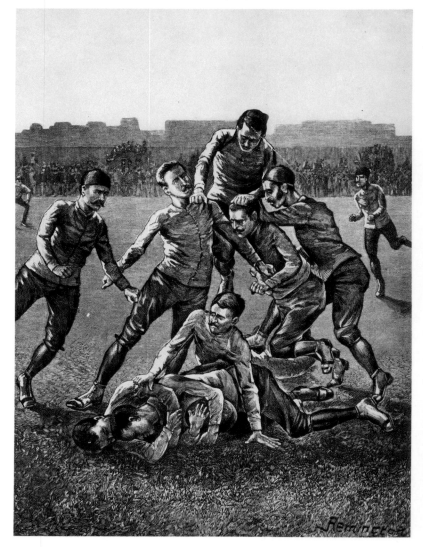

ite subject is soldiers. So is mine." But later on he told Scott: "Don't send me any more women or any more dudes. Send me Indians, cowboys, villains, or toughs, these are what I want."

Not until Remington enrolled at Yale as an art student in the fall of 1878 did he receive any formal instruction. During college Remington came to admire the work of two European painters, Jean Baptiste Edouard Detaille and Alphonse Marie de Neuville, who were noted for their meticulous renditions of the Franco-Prussian War. The young apprentice was inspired by their masterful technique, but also awed by it and seriously questioned whether he could ever reach such heights.

The American artists of the time who were highly regarded for their western scenes had also received their training in Europe and were superb technicians. These included painters such as Albert Bierstadt, Karl Bodmer and Alfred Jacob Miller. But for Remington their paintings lacked the vitality of action and adventure of the West that was so vivid in his own mind. Although he was not aware of it then, he could have found a kindred spirit in his contemporary, Charles Russell, who was destined to follow a similar course. Russell, known as the "cowboy artist," was entirely self-taught, and his style was even less formal than that of Remington.

Remington's experience at Yale had only a few high points. His drawing teacher, John Niemeyer, was considered by many to be unsurpassed in his field. But given that the academic approach to art largely consisted of drawing from plaster casts of classical sculpture, Remington was bored. He found freedom from the classroom on the football field as a rusher for Yale's 1879 team. His football captain was Walter Camp, today known as "the father of American football."

Remington made some progress in art and also made a lifelong friend in the only other student in his art class, Poultney Bigelow. It was Bigelow who turned the *Yale Courant* into an illustrated college weekly, the first in America. Remington was one of the paper's art contributors; his first piece was one of a series of cartoons in the November 1879 issue titled "College Riff-Raff."

All in all, however, Remington felt constricted and discon-

tented at Yale. When his father died in February 1880, Remington was bequeathed a modest inheritance which allowed him to feel somewhat independent. Not long before he would have graduated, he left Yale, much to his mother's chagrin. He dreamed of the West but, succumbing to familial and societal pressure, he found one job and then another as a clerk. Inevitably, Remington's restless spirit railed against this sedentary occupation.

Fortunately for Remington, an unexpected meeting at county fair in Canton, New York, set off a series of events that would lead him toward his destiny. He was introduced to a young woman named Eva Adele Caten who was visiting a

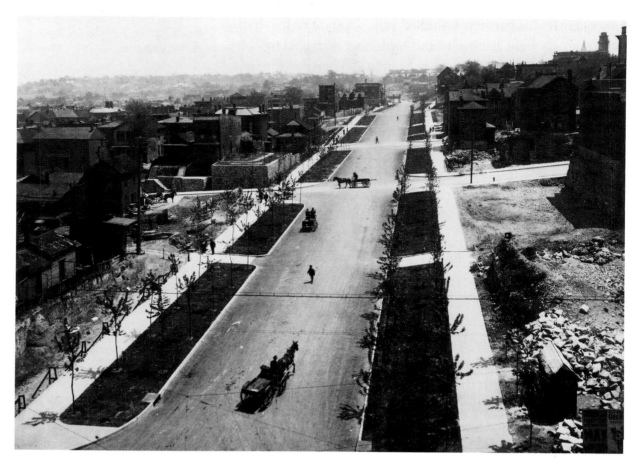

Opposite left: Students at the Yale Art School in the late 1800s, copying classical sculptures.

Opposite: Remington (first row, far right) was a rusher on Yale's 1879 football team, captained by Walter Camp (holding the ball).

Opposite below: A Remington woodcut (1887), depicting early football when the game largely resembled rugby.

Right: A section of Kansas City, Missouri, in the 1880s, around the time that Frederic and Eva moved there.

Below: Eva Caten Remington.

mutual friend. He fell furiously in love with this vivacious, fair-haired beauty and soon rushed off to Gloversville, New York, to request her hand in marriage. But her father rejected the proposal because of Remington's financial instability. Dejected, Remington determined to go west to seek his fortune so that he could return as he put it, "a millionaire," and prove himself worthy to claim Eva for his bride.

Remington's first trip was relatively short. He immersed himself in the culture of the West with an impatient passion. An able horseman, he soon learned how to throw a lariat. He mastered the six-gun and never shied away from a fight. He explored more land west of the Mississippi than many who lived there, always attracted to those places and people least affected by Manifest Destiny, the westward flow of "civilization." He traveled through the Dakotas, Wyoming, Kansas, Montana, the Oregon Trail, the Santa Fe Trail and treacherous territories pioneered by such legendary figures as Kit Carson and Jedediah Smith. He sought out the truly western experience wherever he went, spending time around the encampments of various Indian tribes, riding with cowboys on wagon trains and on horseback through the open cattle range, and following the Indian war trail. He found the company of rugged individuals – trappers, prospectors, mountain men, and outlaws. After only two and a half months he returned east with a portfolio bulging with sketches.

He enjoyed seeing his first drawing in print when *Harper's Weekly* published a redrawn version of his "Cowboys of Arizona" on February 25, 1882. While this initial success gave Remington some confidence, he remained unconvinced he could make a living with his art. When he turned 21 in the fall of 1882 and received the bulk of his inheritance, he headed west again and bought a sheep ranch in Peabody, Kansas. Here,

too, he befriended every western character he could find. He was locally known for his late-night drinking revelries with cowboys and old-timers in saloons. He also socialized with more notable members of society such as the local sheriff and John Mulvaney, painter of a well-known version of Custer's Last Stand. But as success at ranching was not forthcoming and the lure of adventure pulled him, in the spring of 1884 he sold his ranch and wandered even further into the Southwest.

Upon his return to Kansas City, Remington sold some sketches that he had made on his travels. But the fortune that he had set out to acquire so that he could marry Eva still eluded him. He invested what was left of his inheritance into a saloon;

9

Above left: Teddy Roosevelt's Rough Riders were the last elite U.S. cavalry regiment.

Above: Remington at his island retreat, Ingleneuk.

Left: "Twilight of the Indian" (1867) expresses Remington's nostalgia for the Old West.

Opposite above: Shoshone farm lands near Cody, WY, c.1904.

Opposite below: From a series in *Century, Cosmopolitan* and *Collier's,* 1889-1909.

not realized – to experience first-hand a large-scale modern war. In February 1898 when war broke out in Cuba, he headed off as fast as he could to illustrate the action. Although Remington, like many others, was disenchanted with the reality of the Spanish-American War, he produced a series of articles and illustrations for *Harper's Weekly* and Hearst's *Journal,* in addition to some memorable canvases. One of his best known paintings from that time, *Charge of the Rough Riders at San Juan Hill* also served a political purpose, in depicting Theodore Roosevelt leading the charge. Roosevelt was being groomed for the New York gubernatorial campaign, and Remington's picture contributed to the legend of Roosevelt as a soldier. It was unusual for Remington to feature any public figures; he liked to paint the ordinary man, and this was apparently the only instance when Remington used his art to sway public opinion. In fact, Remington made a point of not instilling a message in his art, but simply represented the facts as he saw them.

Remington made his break from illustrator to painter when *Collier's Weekly* commissioned him to paint an exclusive series of pictures to be reproduced in full-color, double-page spreads. The theme and subject matter was left entirely up to Remington, thereby freeing him to paint without constraint. Although he earned less money illustrating by painting then by drawing, he retained the original canvasses, which began to sell for high prices. Some of his most famous paintings were produced for *Collier's;* for example, *His First Lesson* appeared in *Collier's* on September 26, 1903, followed by other such masterpieces of his later years as *Fight for the Water Hole, The Stampede* and *With the Eye of the Mind.*

The success that met his paintings in *Collier's* was reinforced by the many exhibitions of his original paintings held in the early twentieth century. Everyone agreed, as the foremost art critic of the day, art editor of the *New York Herald Tribune,* wrote that, "the mark of the illustrator disappeared and that of the painter took its place." Remington responded in kind,

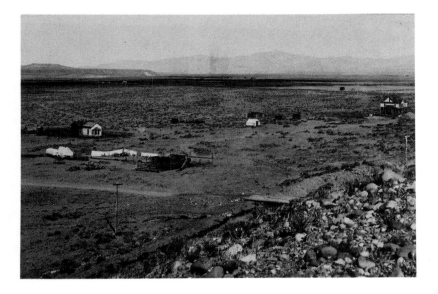

working at a feverish pace. He often produced several large canvasses each month, enabling *Collier's* to print two or three in every issue.

With the dawning of the new century, Remington's paintings rose above his former literal, linear style. Remington worked with freer brush strokes and liberal applications of color in a more impressionistic, painterly fashion. The work of the European Impressionists, especially Claude Monet, influenced him. Remington focused on capturing the aura of the West with effects of light and color. His West lived now only in his mind, becoming more romanticized. He painted brilliant sunlit scenes and eery moonlit nocturnals that suggested, rather than detailed, lurking elements of suspense and action.

As the century was coming to a close and Remington was approaching his fortieth birthday, he mourned the passing of the West. "The West is no longer the West of picturesque and stirring events," he said. "Romance and adventure have been beaten down in the rush of civilization . . . My West passed out of existence so long ago as to make it merely a dream."

Remington's athletic physique was also a thing of the past. His love of good food and fine wine were taking their toll; he had put on so much weight that he was no longer fit to ride a horse. But he abided by his theory that, "every man should get up a real sweat at least once a day," and still swam and played tennis. As his trips out West were less frequent, he longed to escape the life of the city and the encroaching suburbia of New Rochelle. In 1898 he bought an island, "Ingleneuk on the St. Lawrence River" near his roots in northern New York State. There, he and Eva relaxed in the summers.

He reveled in his solitary kingdom, away from the distractions of urban life. He was free to canoe and to produce prodigious amounts of prose as well as art. Despite his physical deterioration, he maintained his rigorous work schedule. He wrote numerous articles and several books, competing with the school of western writers of his day – such as Owen Wister, Bret Harte, Alfred Henry Lewis, Joaquin Miller and Stewart Edward White. Although he never achieved the type of fame as a writer that he did as an artist he was considered by many to be, as Theodore Roosevelt said, among the "very best."

By 1909 the Remingtons had moved once again. This time in Ridgefield, Connecticut, Remington built a large house of his own design and a studio that would "fit a trooper on horseback." That summer he completed some of his finest paintings including *The Outlier, Among the Led Horses, The Buffalo Runners,* and what many critics considered his preeminent sculpture, *The Stampede.* In December, his exhibition of 23 paintings at New York's prestigious Knoedler Gallery was his finest hour. His work received unequivocal praise from critics and the public. In the words of one reviewer: "Remington's work is splendid in its technique, epic in its imaginative qualities, and historically important in its prominent contributions to the most romantic epoch in the making of the West."

Three weeks after the exhibition opened, Remington's "bellyache," of which he had been complaining, became quite severe. After several consultations his doctors decided to perform an emergency operation for appendicitis. Although the operation at first seemed successful and he recovered enough to enjoy Christmas day, by the next morning he died. He was 48 years old and at the peak of his career.

Remington had achieved everything, and more, that he had set out to do. He never compromised his artistic ideals to conform to the aesthetic standards of the day and, nonetheless, became one of the most celebrated artists in America. He left nearly three thousand works of art, which provide an indelible record of an era of American history and of its ordinary people. President Theodore Roosevelt paid a fitting tribute to Remington in a letter he sent to the editor of *Pearsons* in 1907:

> He is, of course, one of the most typical artists we have ever had, and he has portrayed a most characteristic and yet vanishing type of American life. The soldier, the cowboy and rancher, the Indian, the horses and cattle of the plains, will live in his pictures and bronzes, I verily believe, for all time.

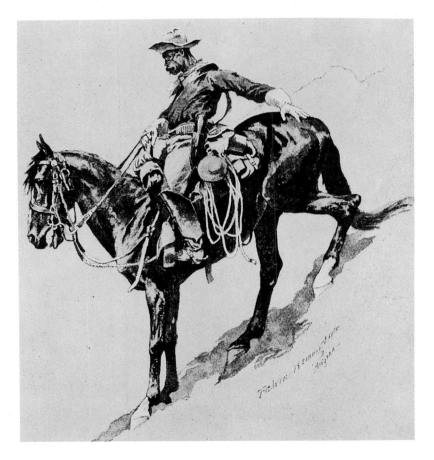

MILITARY SCENES

Ever since Remington was a boy, he had dreamed of battle. He idealized heroic images of plucky soldiers fighting in the face of tremendous obstacles, doing their duty for God and country. In particular he admired the camaraderie of the exclusively male military domain, which was cemented by shared experiences on the battlefield and in the wilderness. Remington's paintings, drawings, sculptures and writings immortalized the "boys in blue."

Describing an evening he spent with some soldiers, huddled inside a tent during a raging blizzard, Remington said:

> The soldiers sit in their camp-drawing room buttoned up to the chin in their big canvas overcoats . . . The freemasonry of the army makes strong friendships, and soldiers are all good fellows, that being a part of their business. . . . They have met before, and the memory after memory comes up with its laughter and pathos of the old campaigns.

Equal to Remington's passion for the military was his love of horses. Military scenes allowed him to work with his two favorite subjects. Remington depicted dynamic battle scenes as no one had before: the sweat, dirt and grim determination of soldiers astride horses with pounding hooves and flying manes. Whenever he portrayed soldiers – fighting Indians, setting up camp, or as solitary figures – they were nearly always accompanied by their dependable steeds.

By the time Remington was born, most regiments of the U.S. army were mounted. The first such regiment of the Dragoons was raised in 1833 to serve against the Plains Indians. By 1848 the army had three branches of mounted services, the largest of which was the cavalry, in which Remington's father served in the Civil War. During Remington's lifetime military scenes regularly included horses.

Remington was able to recreate the thrill of battle, despite his limited experience of war. Most of his pictures were based on the frequent encounters he had with military expeditions and his experiences accompanying the U.S. army scouting parties out West. His only first-hand opportunity was in 1898 when he participated in the Spanish-American War in Cuba. Remington learned that war was not as glamorous as his ideal. His account *Charge of the Rough Riders at San Juan Hill* depicted only Theodore Roosevelt on horseback while the other members of the unit scurried behind. Moreover, he was struck with the harsh reality of suffering he saw behind the lines.

Remington brought to life not only the excitement, but the turmoil and tension of warfare. With his power of observation and his fertile imagination he produced an extraordinary legacy of the countless anonymous soldiers who fought in the West. As Owen Wister remarked about Remington's illustrations in the introduction of *Done in the Open* in 1902:

> Remington is drawing his contemporary history of the most picturesque of the American people. Never until this particular day have we possessed a recorder who should give to posterity the enlisted man to be put alongside with the captain who led him into battle.

Cavalryman of the Line, Mexico, 1889
1889, oil on canvas, 24⅛×20⅛ in.
Amon Carter Museum, Fort Worth, TX

Pages 18-19:
Drum Corps, Mexican Army, 1889
c.1889, oil on canvas, 18⅛×28⅛ in.
Amon Carter Museum, Fort Worth, TX

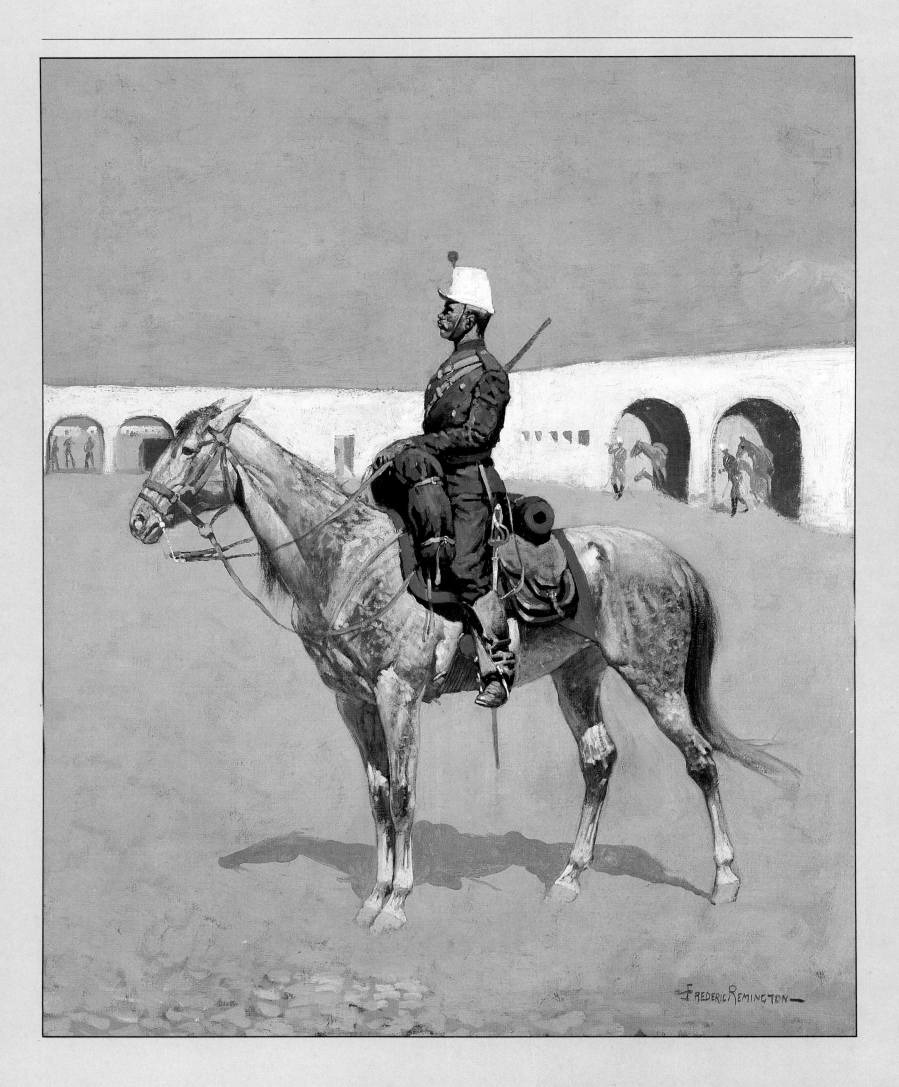

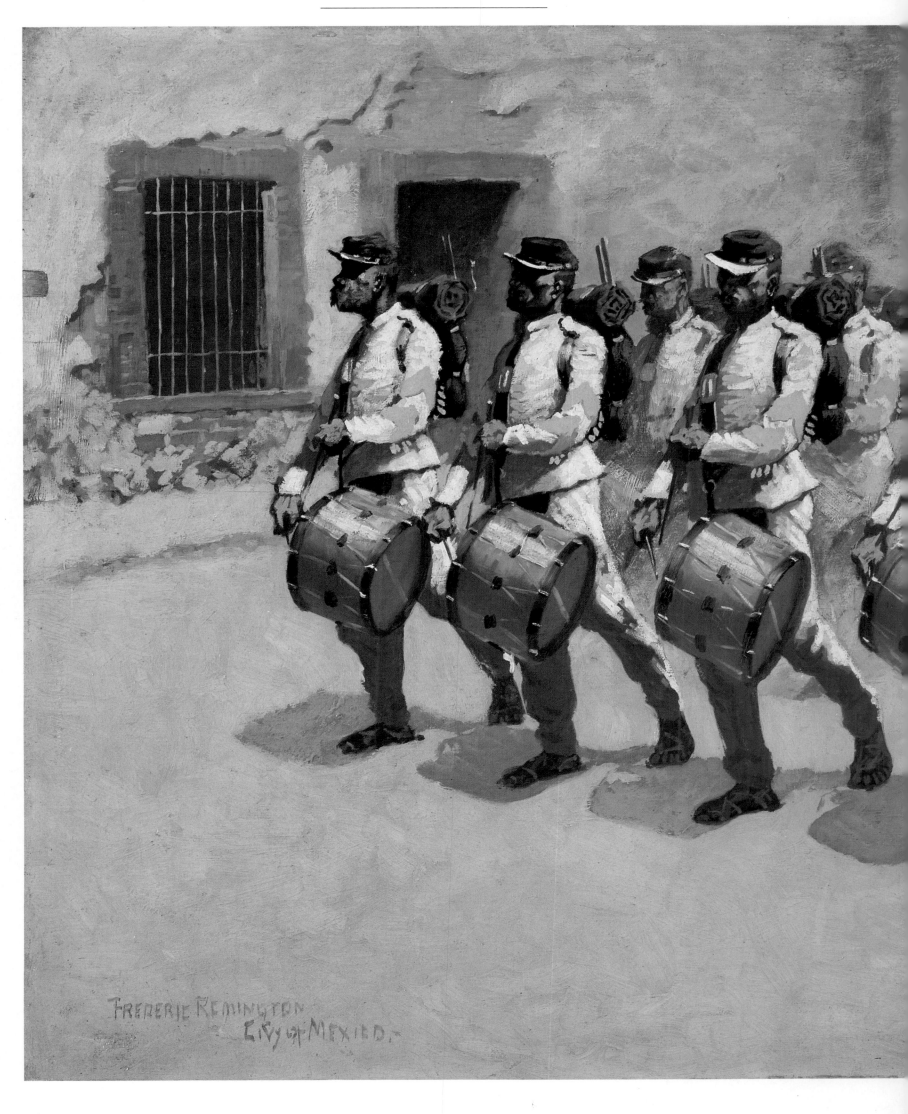

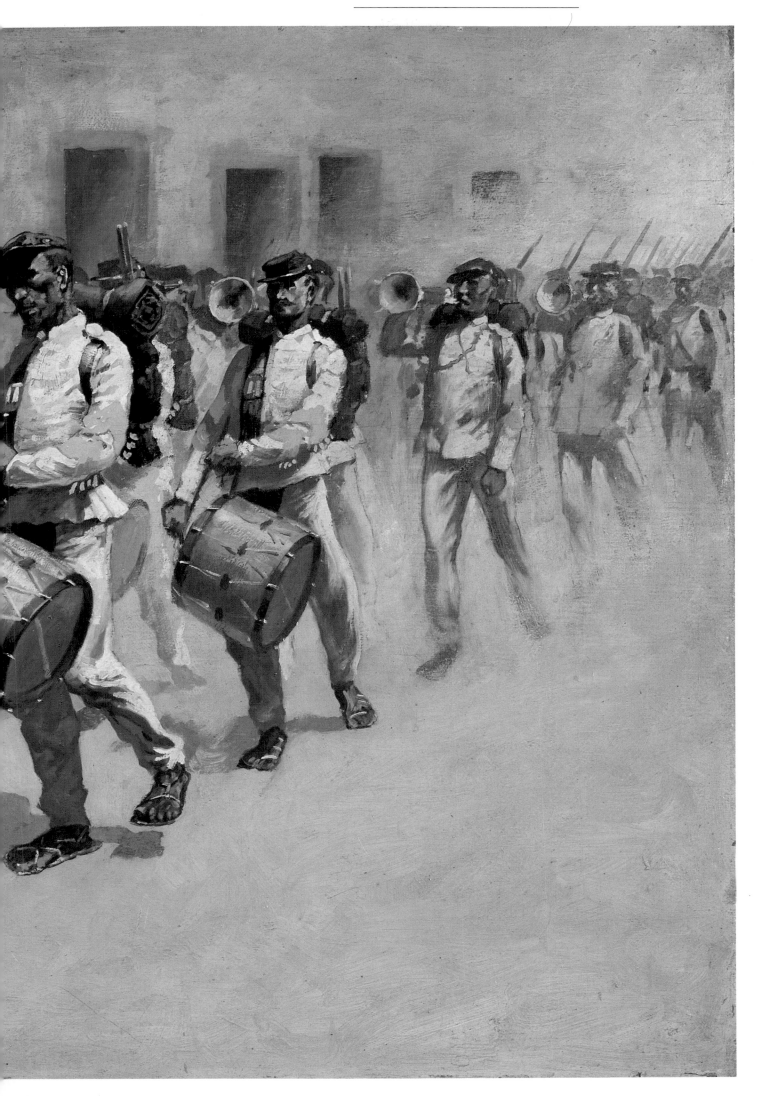

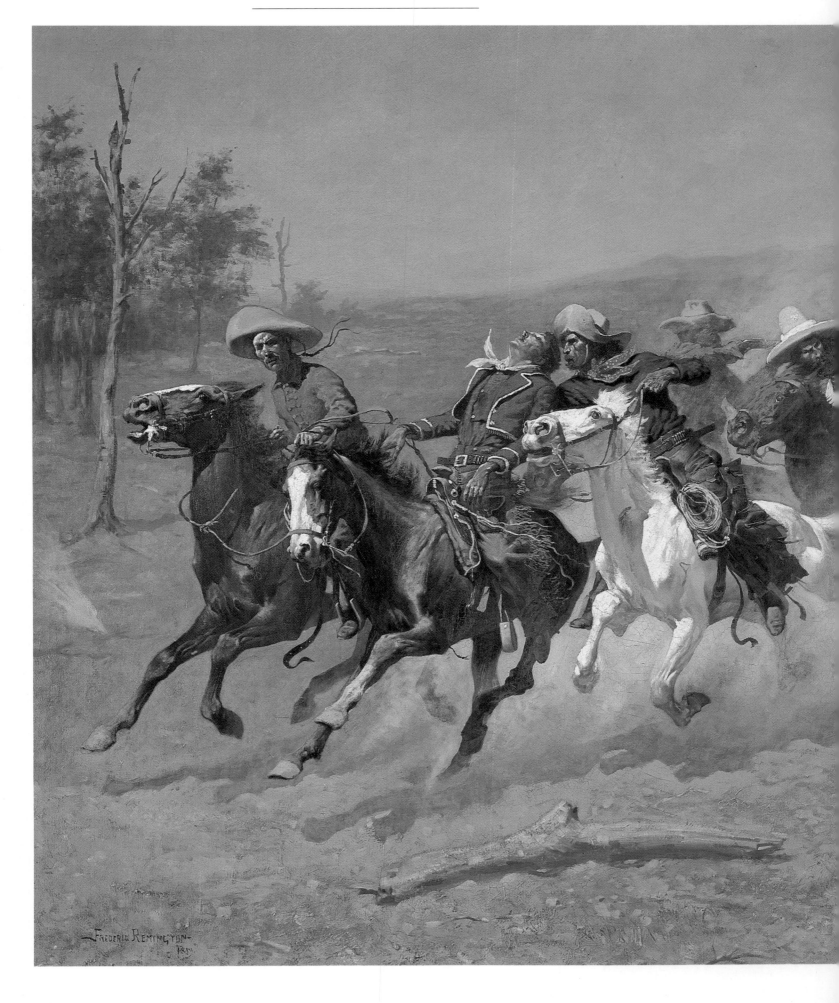

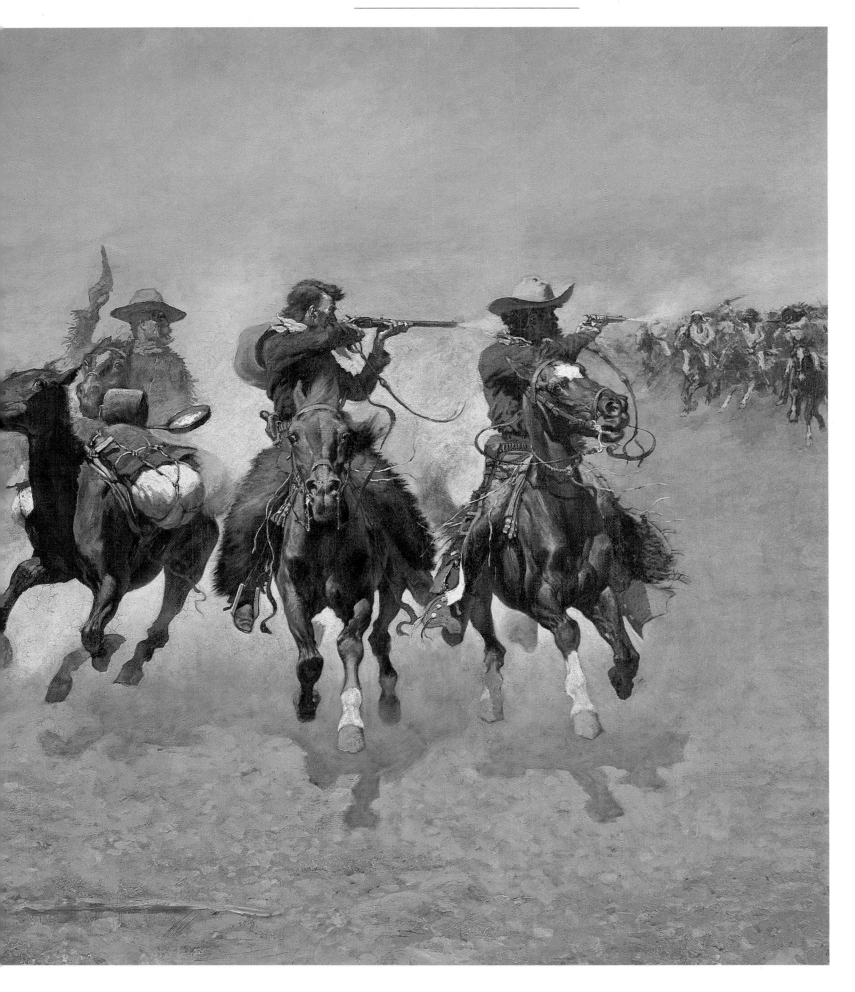

A Dash for the Timber
1889, oil on canvas, 48¼×84⅛ in.
Amon Carter Museum, Fort Worth, TX

Pages 22-23:
Cavalry in an Arizona Sandstorm
c.1889, oil on canvas, 22⅛×35¼ in.
Amon Carter Museum, Fort Worth, TX

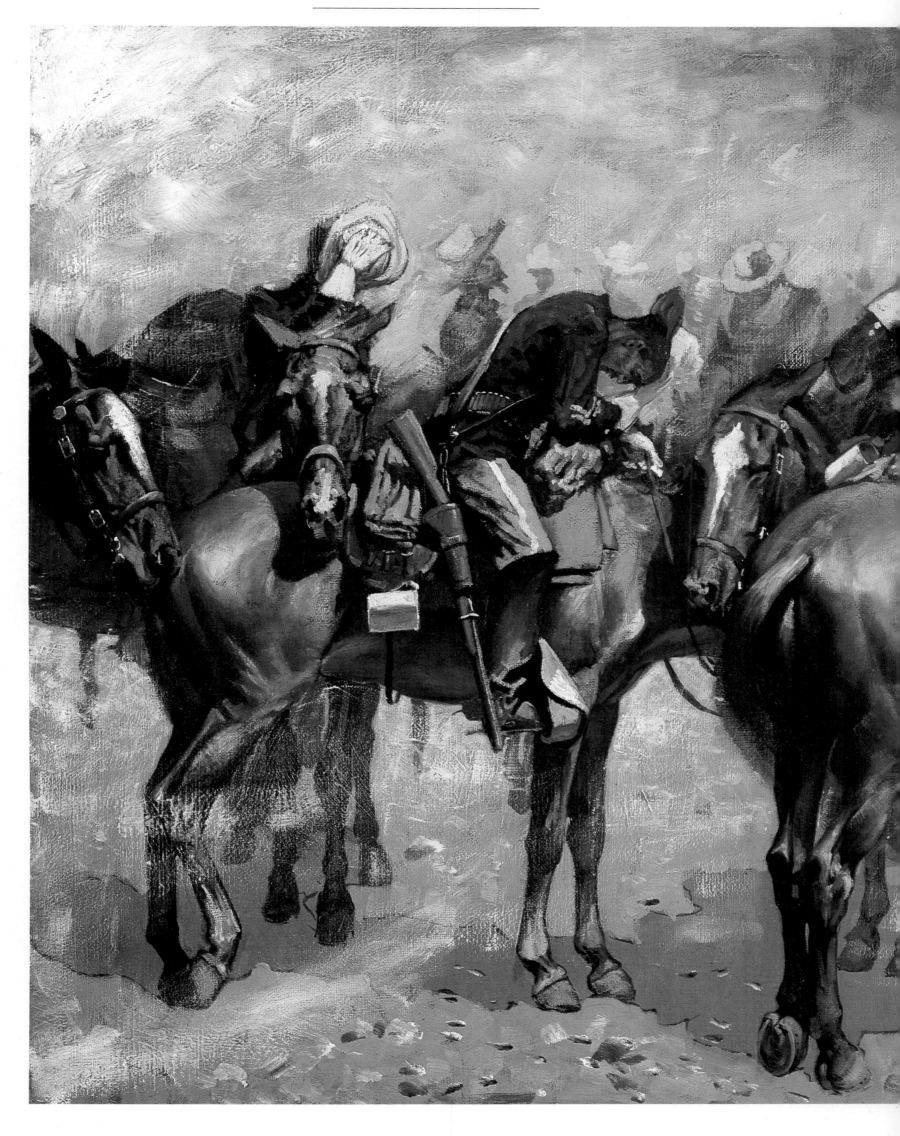

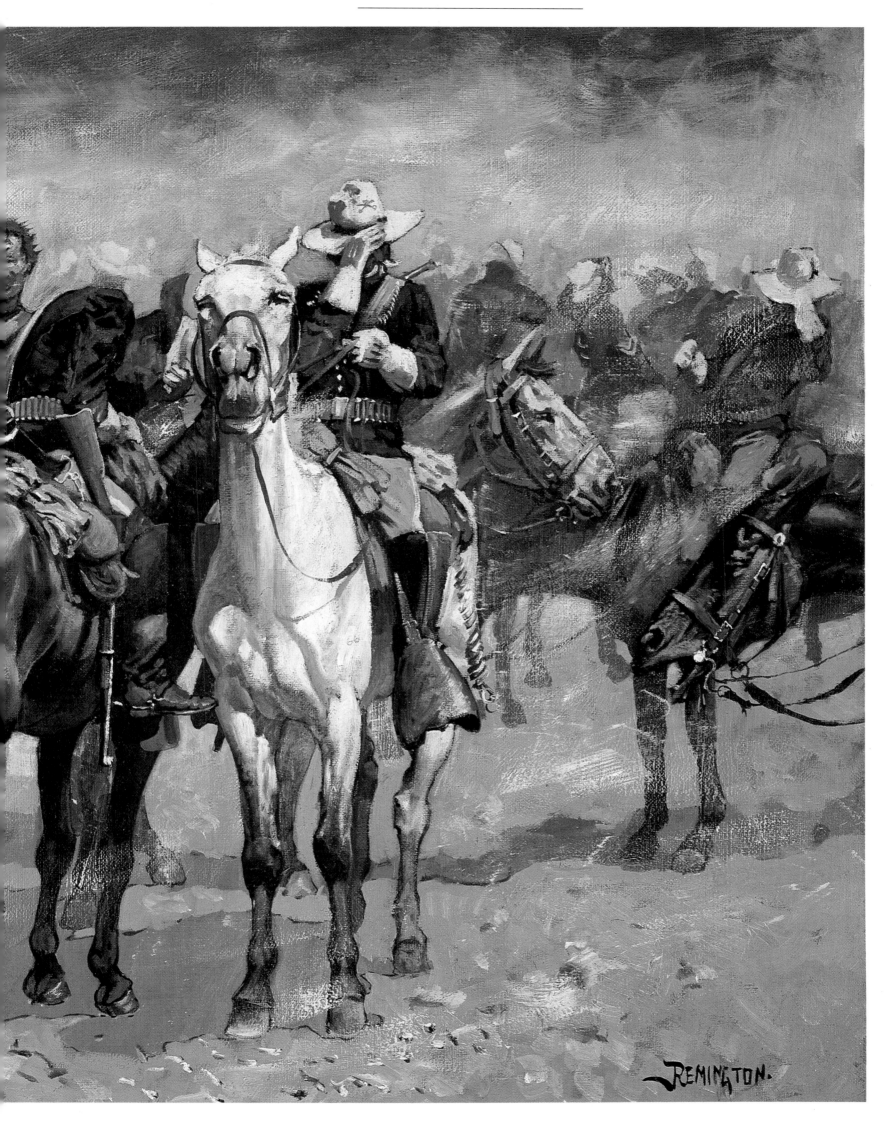

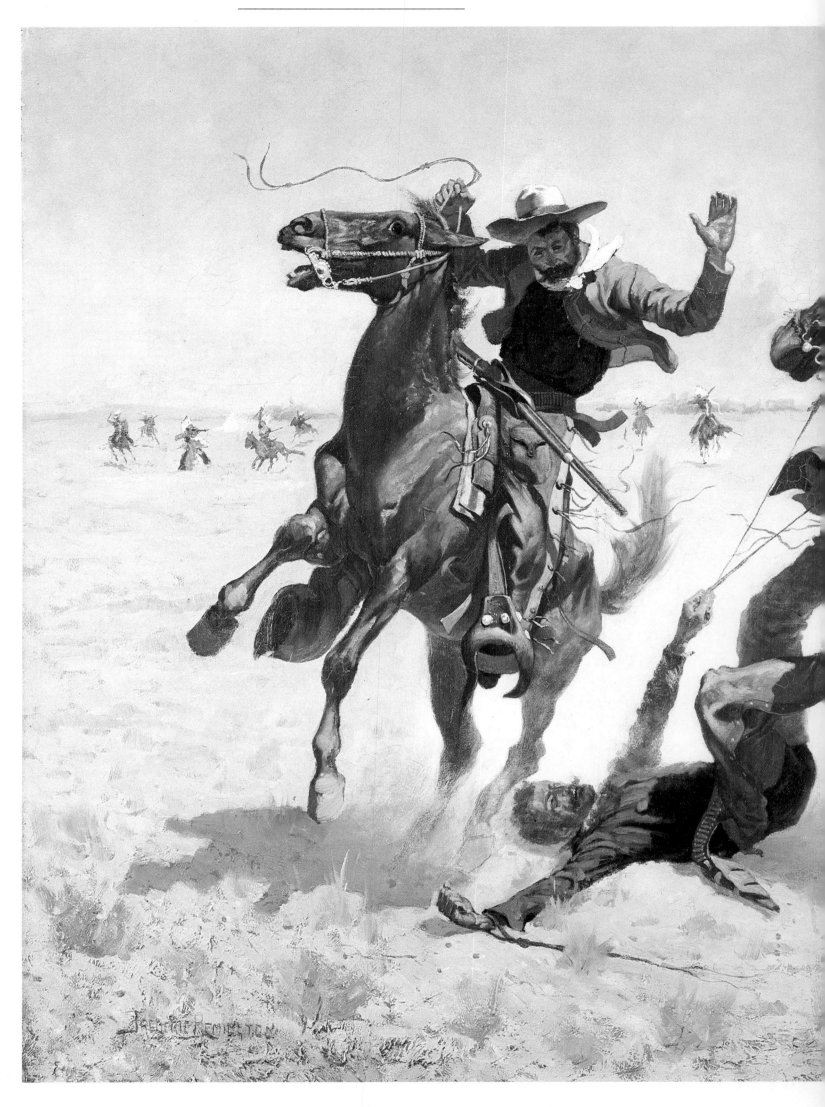

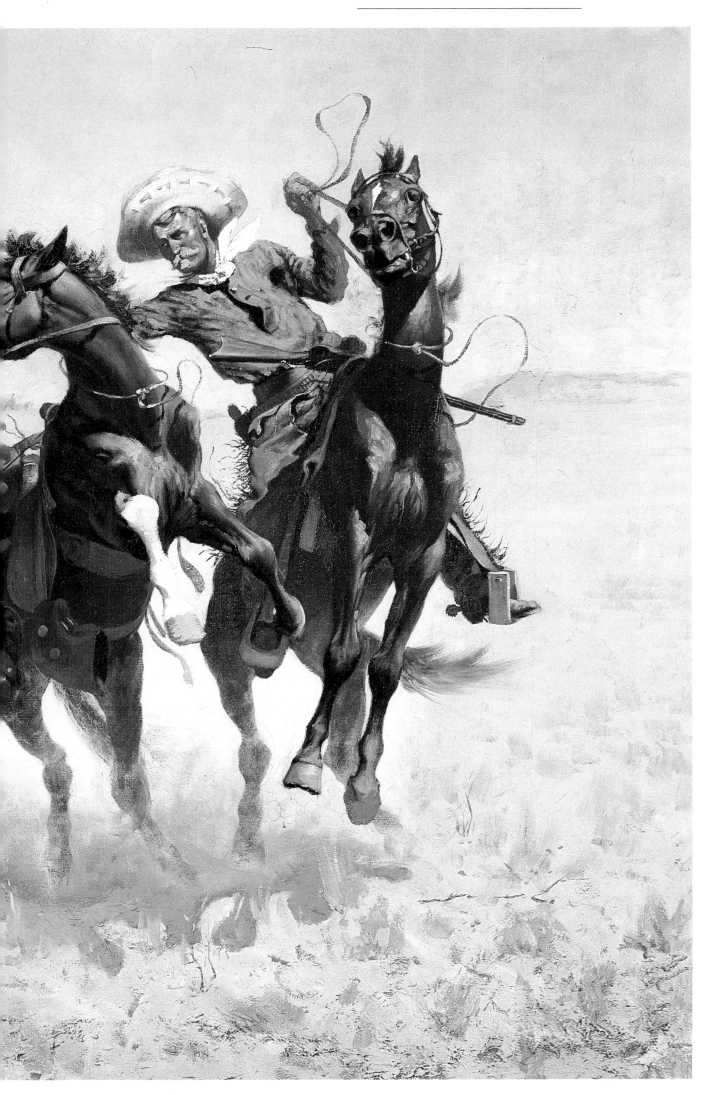

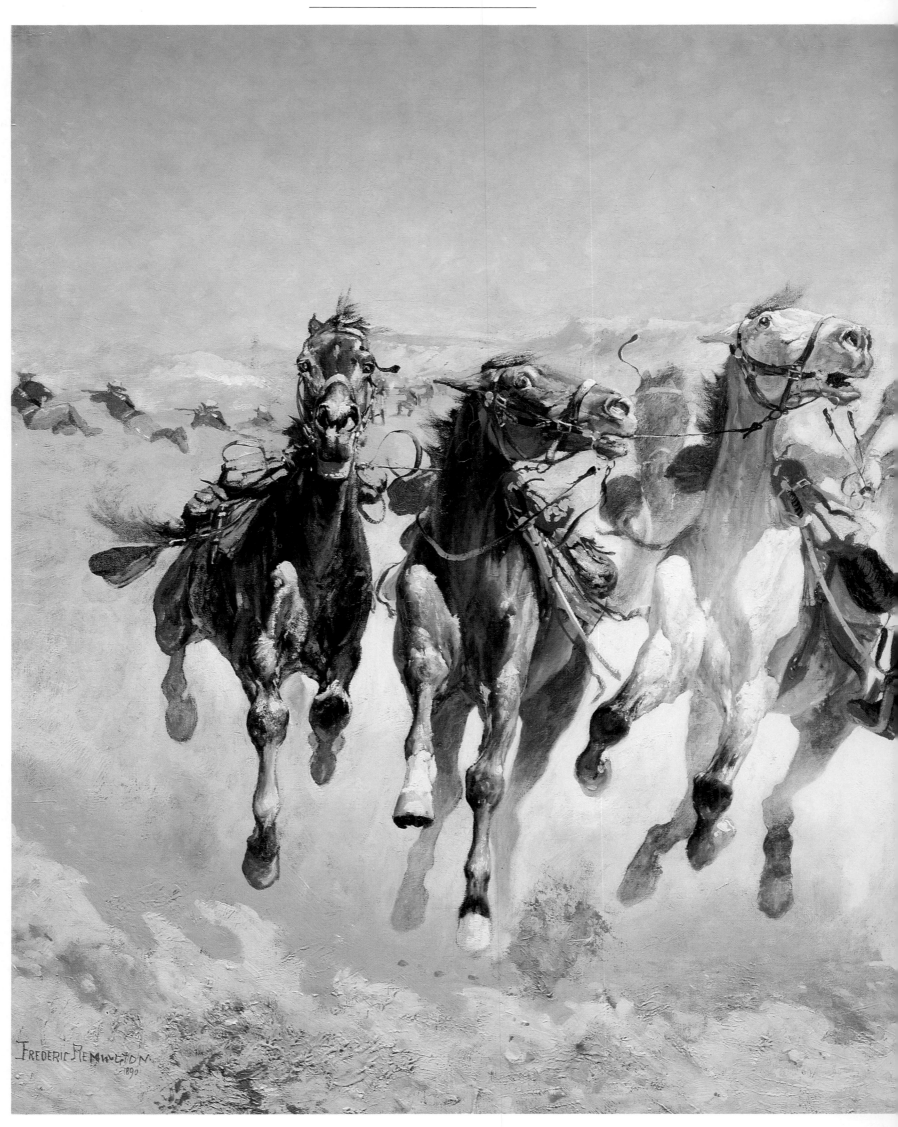

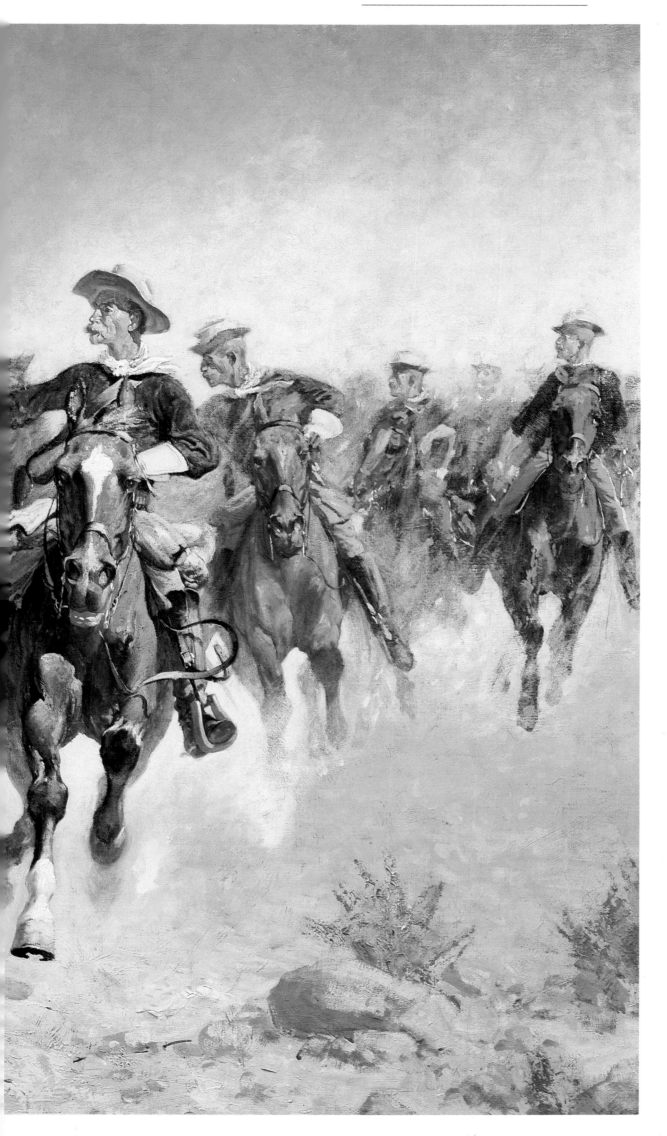

Pages 24-25:
Aiding a Comrade
c.1890, oil on canvas, 34×48 in.
The Hogg Brothers Collection,
Museum of Fine Arts, Houston, TX

Dismounted: The Fourth
Troopers Moving the Led Horses
1890, oil on canvas,
34 1/16 × 48 15/16 in.
Sterling and Francine Clark Art
Institute, Williamstown, MA

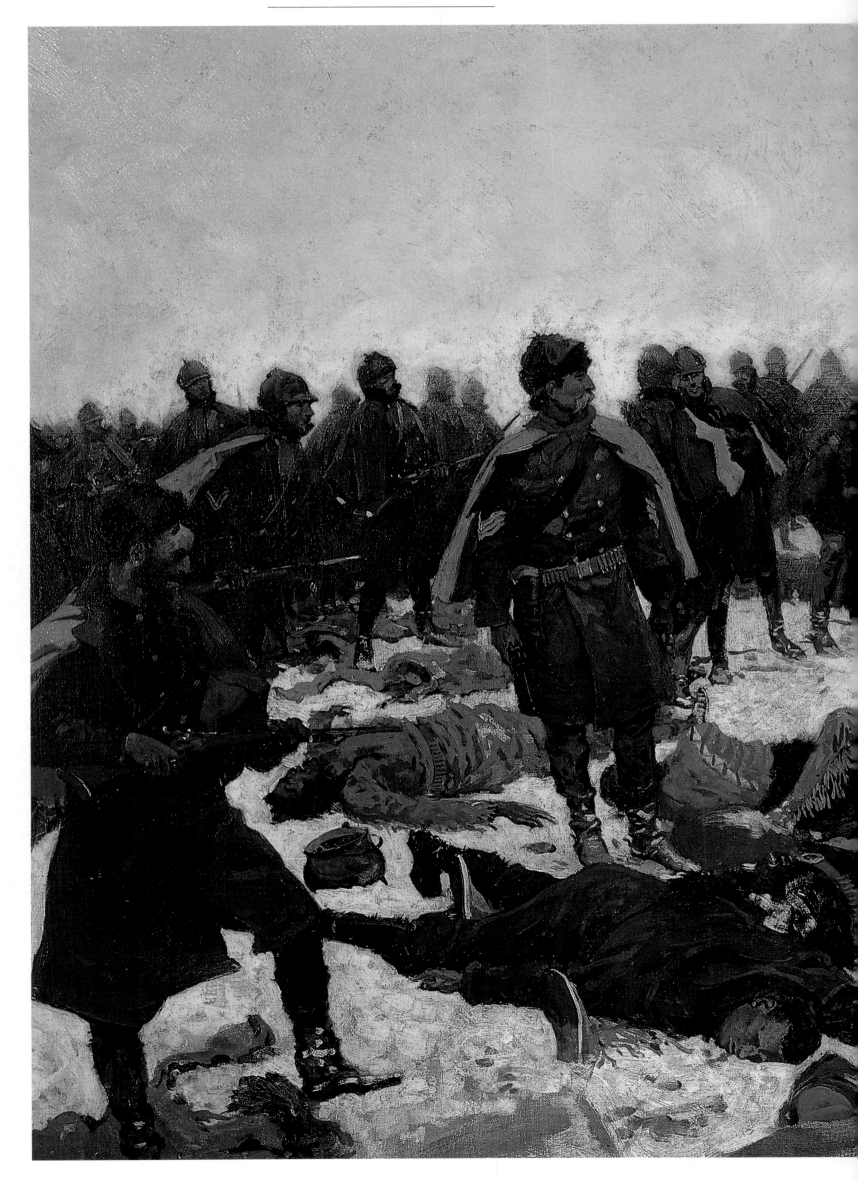

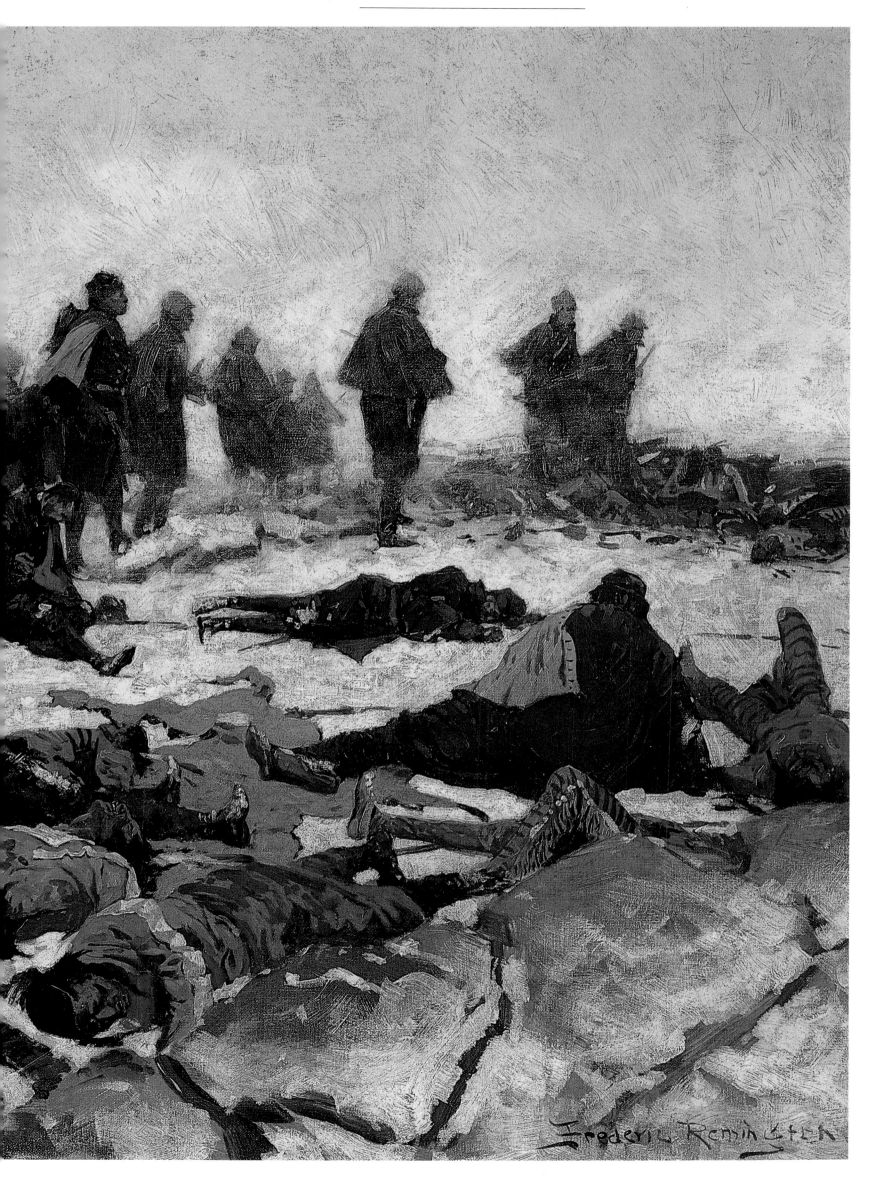

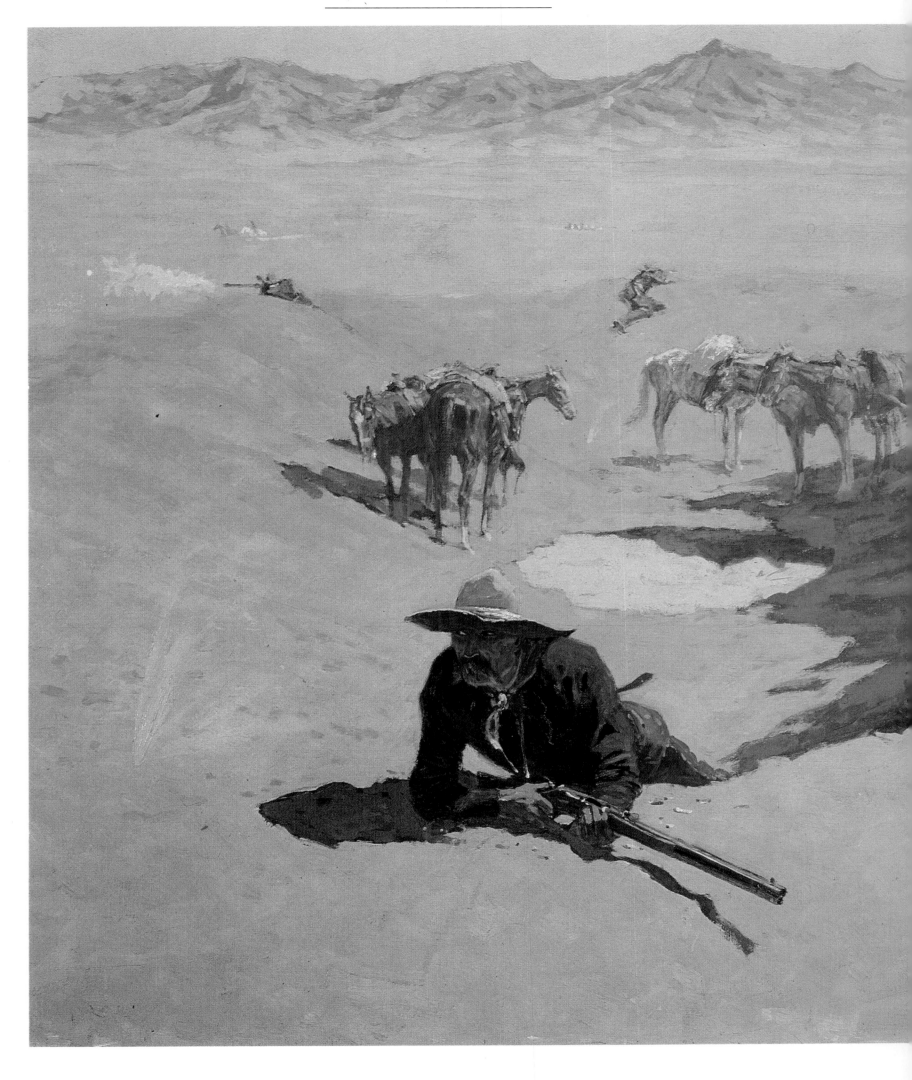

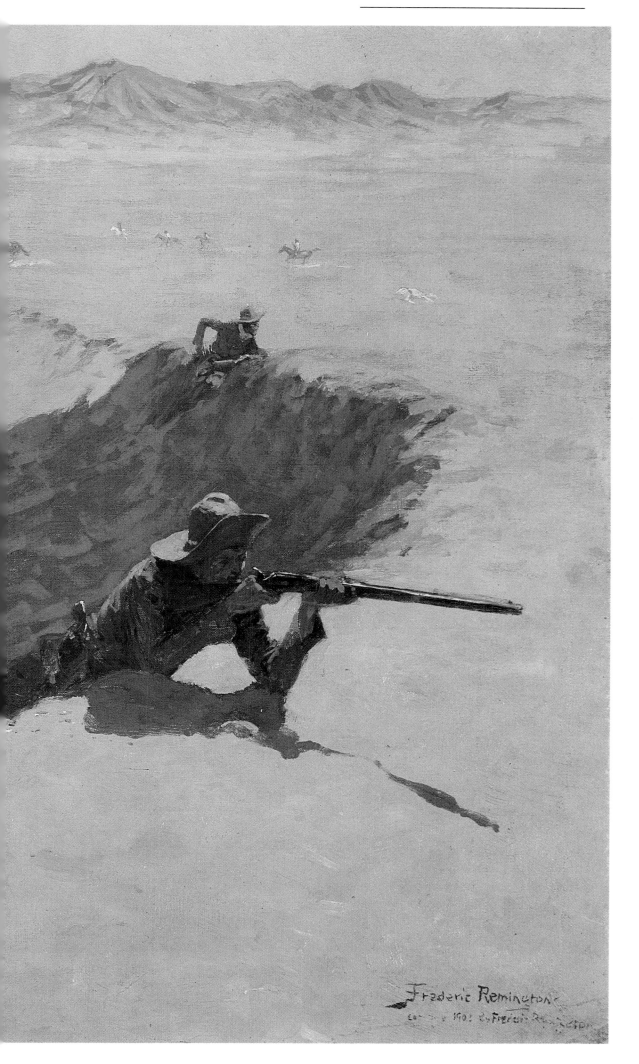

The Fight for the Waterhole
1901, oil on canvas, 27×40 in.
*The Hogg Brothers Collection,
Museum of Fine Arts, Houston, TX*

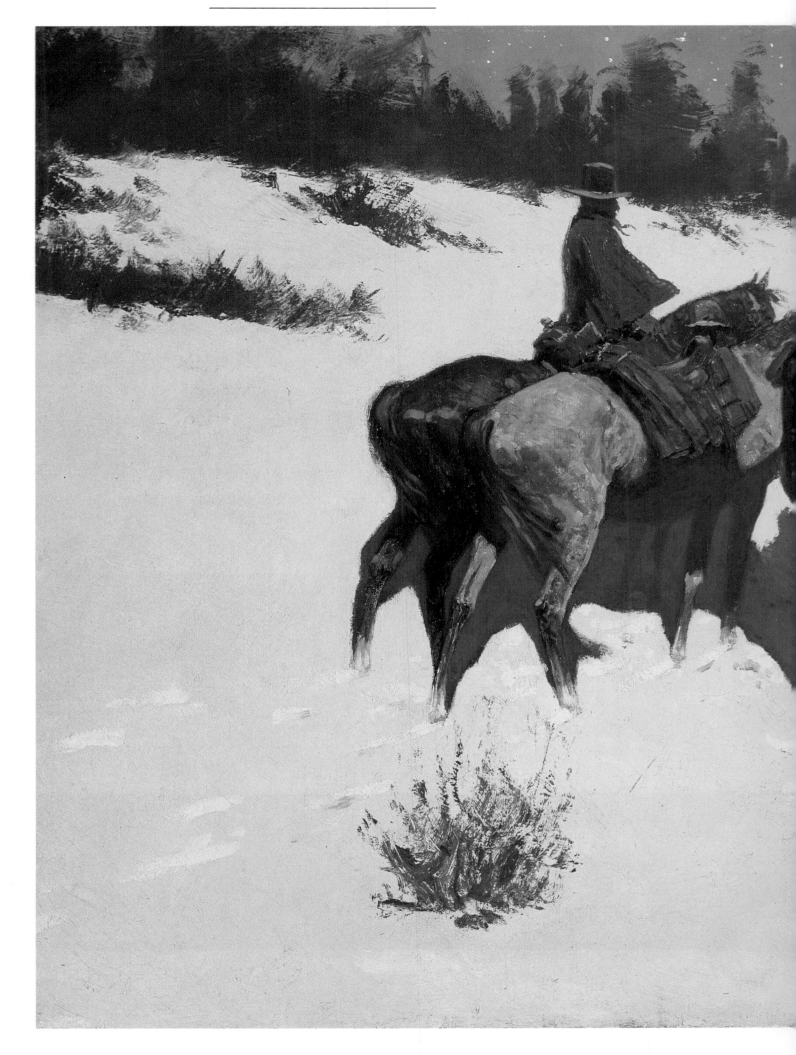

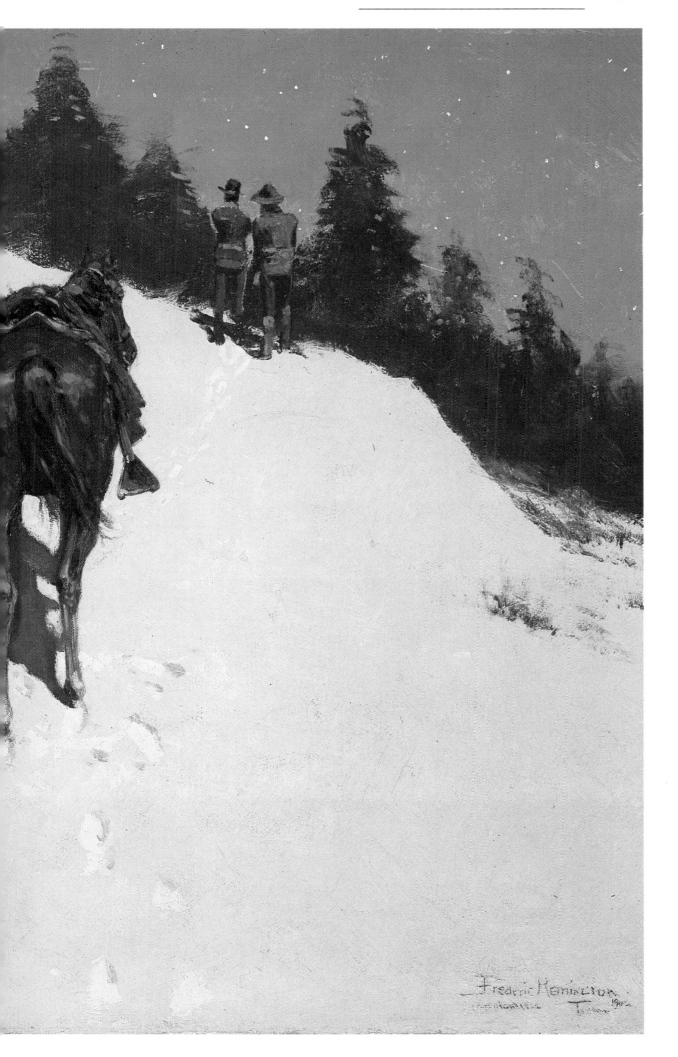

A Reconnaissance
1902, oil on canvas, 27×40⅛ in.
Amon Carter Museum, Fort Worth, TX

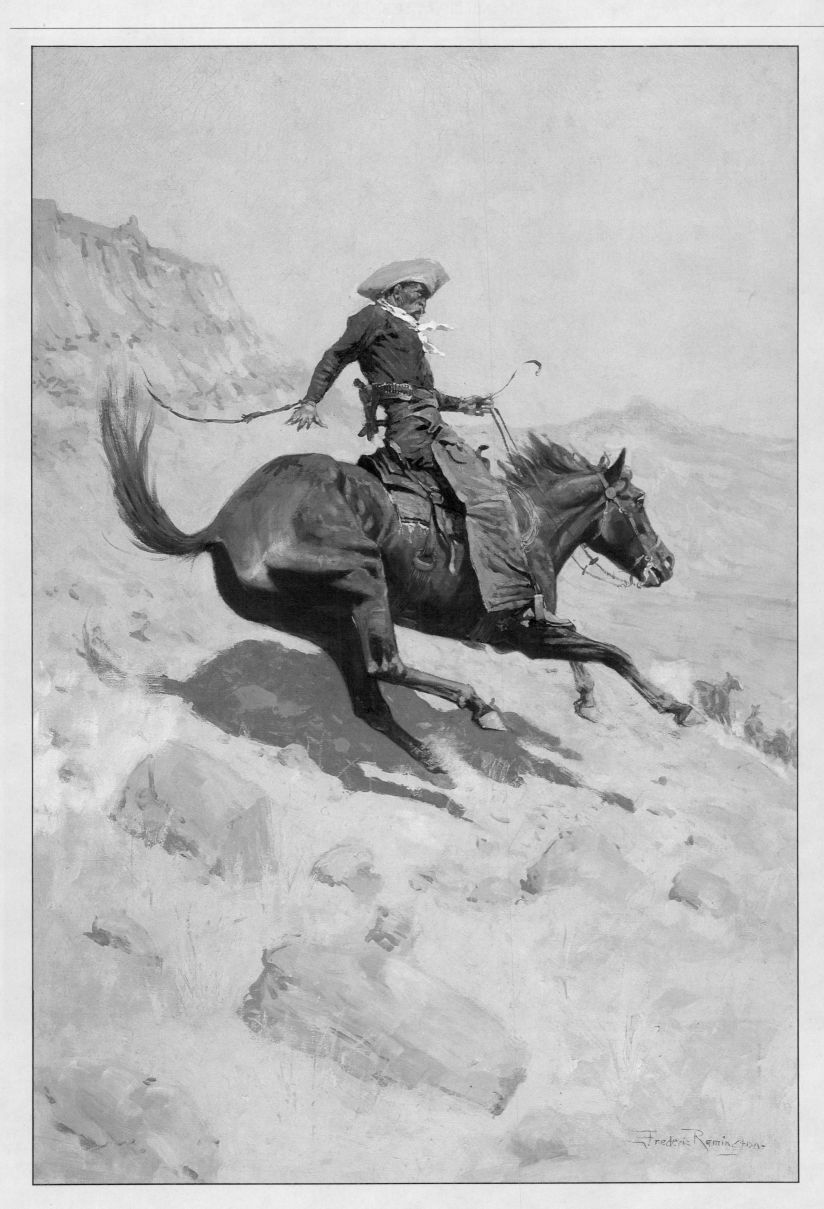

COWBOYS AND OTHER FRONTIERSMEN

Remington's attraction to drawing cowboys stemmed as much from his admiration for the horses they rode as to the wild life they led. The cowboys Remington encountered were rugged characters who herded cattle on the long drive from Texas to the northern ranges, traveling across unclaimed and often uncharted territory on their broncos. During the solitary months on the trail, they struggled against the perils of droughts, storms, and turbulent rivers, always alert to the threat of a stampede or attack from unfriendly Indians.

Remington had studied the history and the lineage of horse breeds and arrived at the conclusion that

> As a saddle animal simply, the bronco has no superior . . . He graces the Western landscape, not because he reminds us of the equine ideal, but because he comes of the soil, and has borne the heat and the burden and the vicissitudes of all that pale of romance which will cling about the Western frontier.

The western writers of the day romanticized this image of the cowboy, and Remington set the scene. From his early intricately detailed drawings to his later more impressionistic and most lauded works, he featured the reckless cowboy and his bronco – ranching, herding, and hunting. For Remington and many of his contemporaries, the cowboy epitomized what a man should be – tough, courageous, occasionally warm, and capable of enduring great hardships.

The original cowboys were the Mexican vaqueros on the Rio Grande. From the vaqueros the Texan cowboys adapted much of their equipment – the big-horned saddle, the spade bit, rawhide rope, and their expressions such as *remuda* (spare horse) and lariat. By the time Remington lived in the West the Texan cowboys had assumed their own unique style, which Remington documented for posterity.

Remington also recorded the lives of other adventurers – the settlers, pioneers, prospectors, mountain men, trappers and outlaws who were an integral part of the western scene. As he traversed the wildest parts of the West, Remington searched for the old-timers whose experiences he would assimilate to broaden his perspective and his art. In his later years he painted the wilderness of New York State where he spent more and more time canoeing, fishing, and enjoying the sunsets at his island home Ingleneuk.

Poultney Bigelow, the editor of *Outing* magazine who early on recognized Remington's genius, complemented Remington upon seeing his drawings:

> Here was the real thing, the unspoiled native genius dealing with Mexican ponies, cowboys, cactus, lariats and sombreros. No stage heroes these; no careful pomaded hair and neatly tied cravats; these were the men of the real rodeo, parched in alkali dust, blinking out from barely opened eyes under the furious rays of the Arizona sun.

The Cowboy
1902, oil on canvas, 40¼×27⅜ in.
Amon Carter Museum, Fort Worth, TX

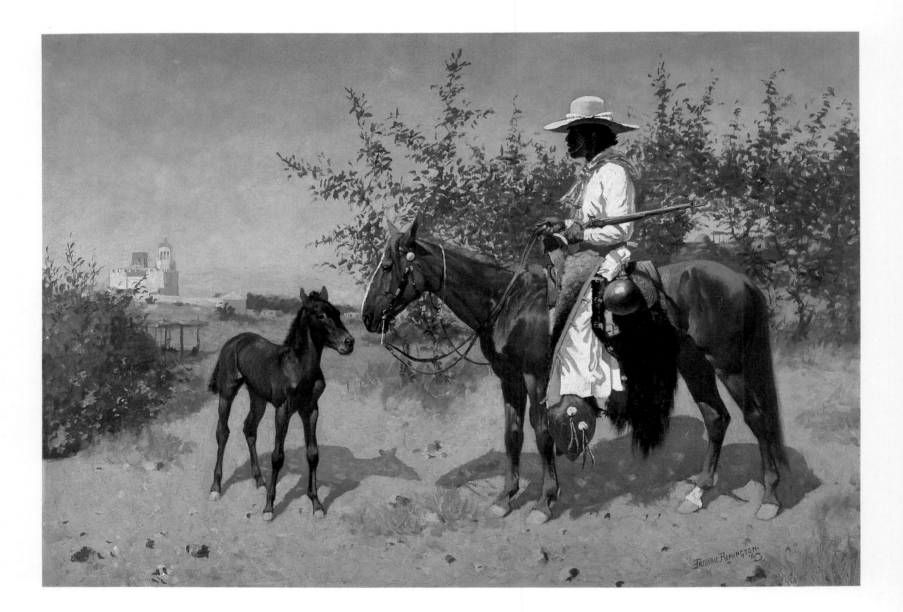

The Sentinel, 1889
1889, oil on canvas, 34×49 in.
Sid Richardson Collection of Western Art, Fort Worth, TX

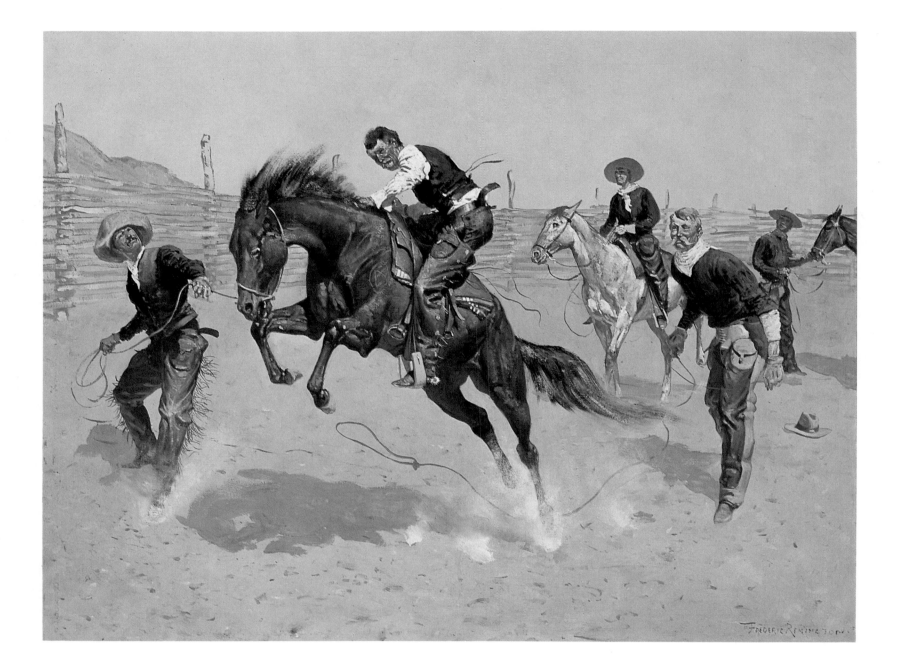

Turn Him Loose, Bill
1892, oil on canvas, 25×33 in.
The Anschutz Collection, Denver, CO

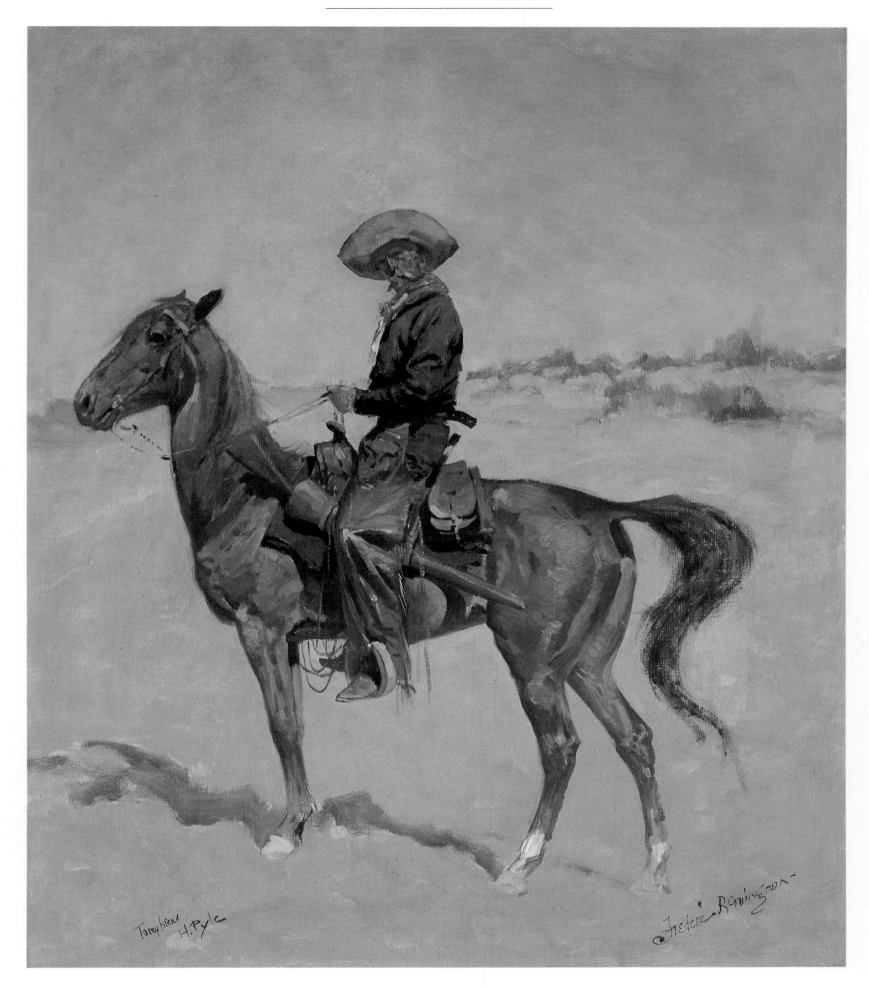

The Puncher
1895, oil on canvas, 17¾×14⅞ in.
Sid Richardson Collection of Western Art, Fort Worth, TX

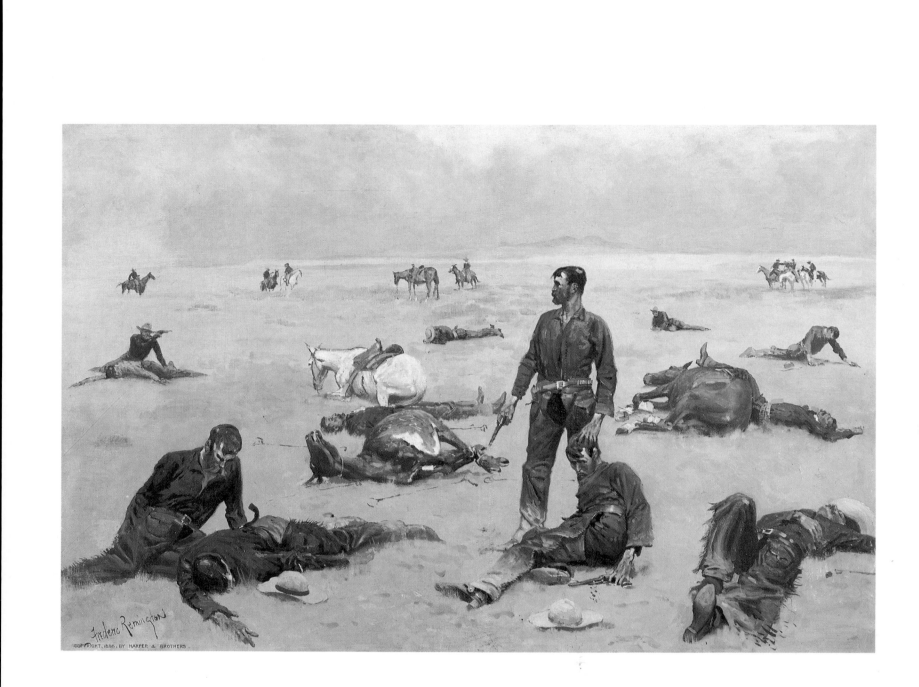

What an Unbranded Cow Has Cost
1895, oil on canvas, 28⅙×35⅛ in.
Gift of Thomas M. Evans, Yale University Art Gallery, New Haven, CT

53

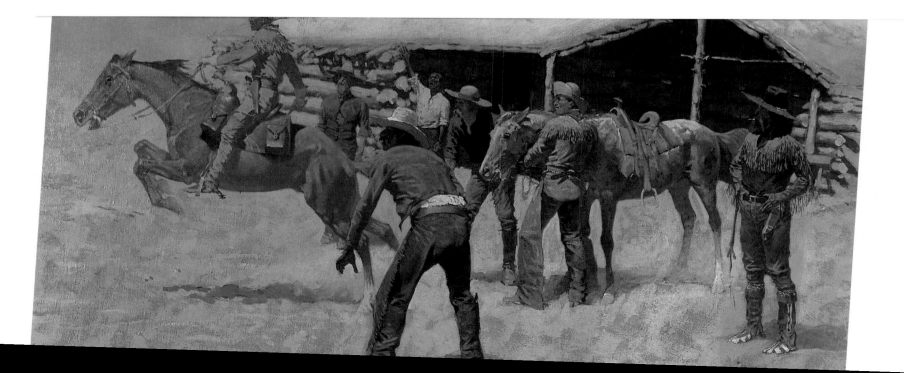

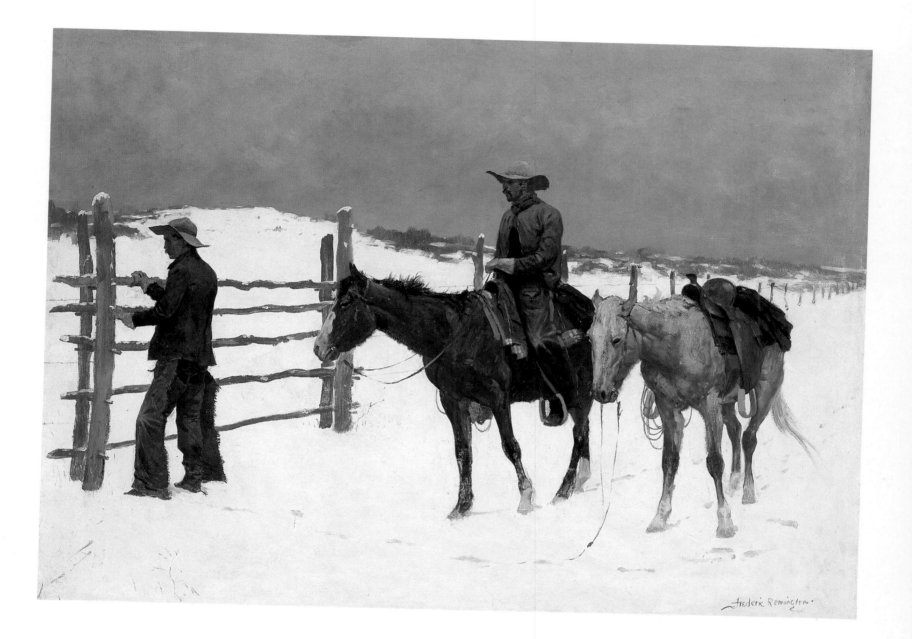

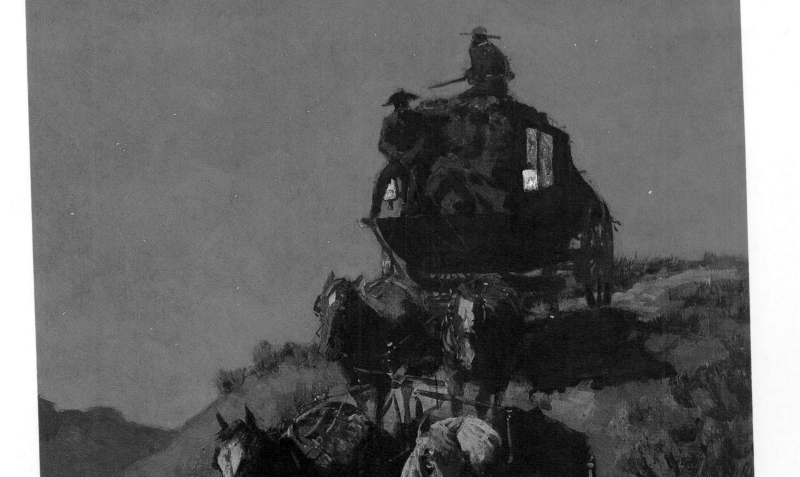

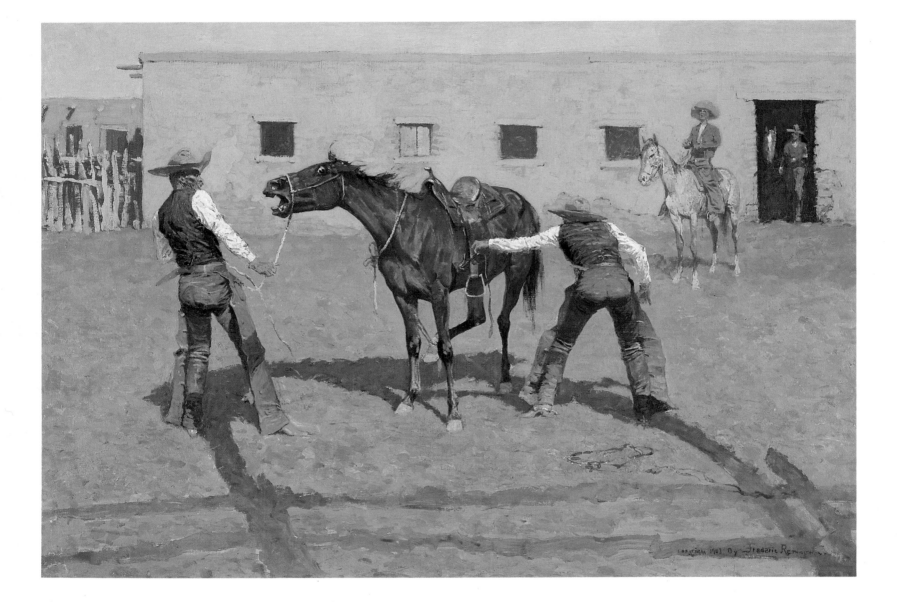

The Old Stagecoach of the Plains
1901, oil on canvas, 40¼×27¼ in.
Amon Carter Museum, Fort Worth, TX

His First Lesson
1903, oil on canvas, 27¼×40 in.
Amon Carter Museum, Fort Worth, TX

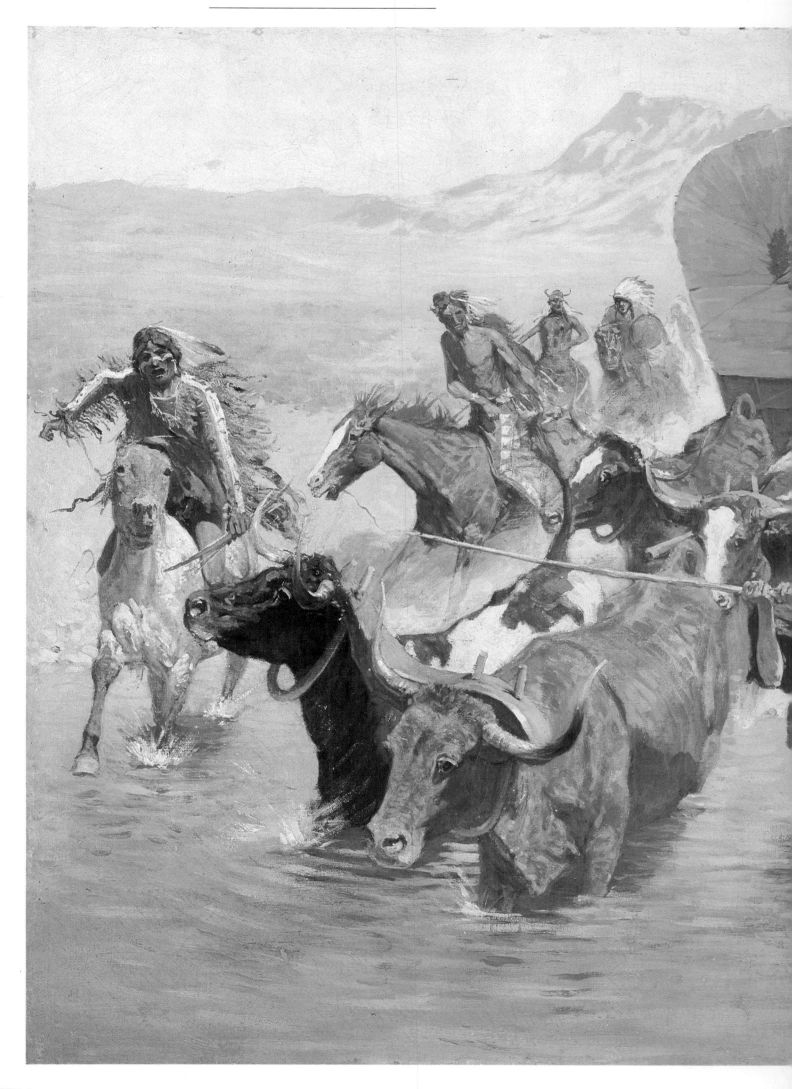

The Emigrants
1904, oil on canvas, 30×45 in.
The Hogg Brothers Collection, Museum of Fine Arts, Houston, TX

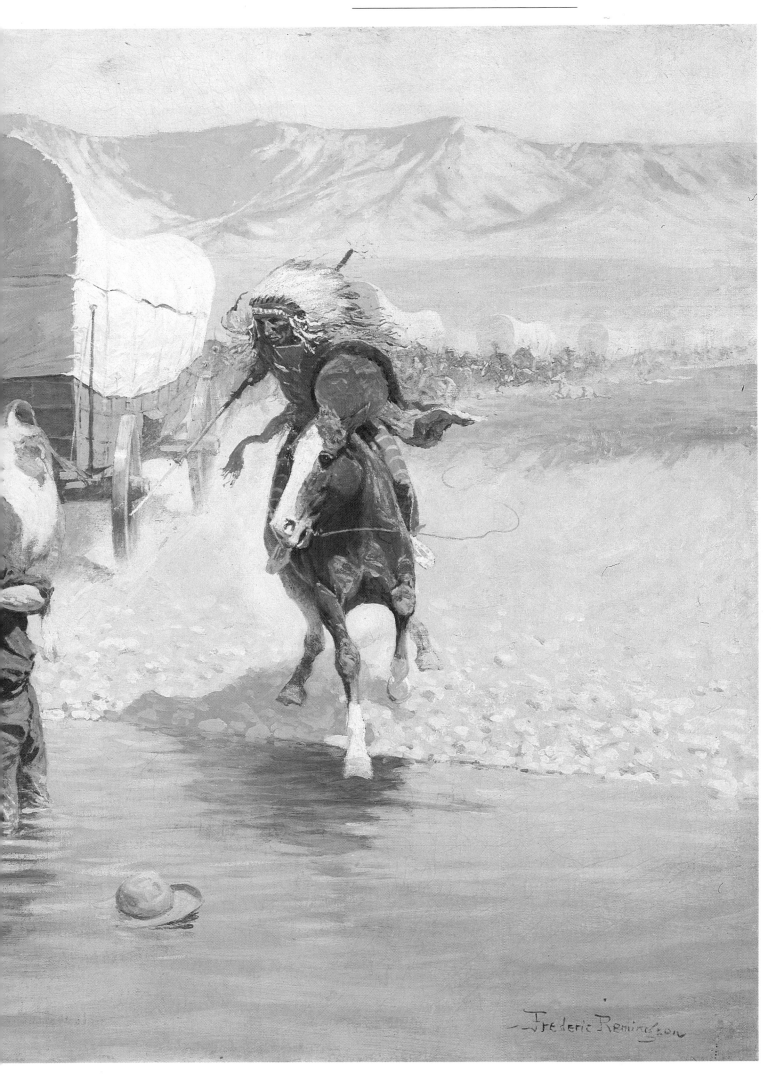

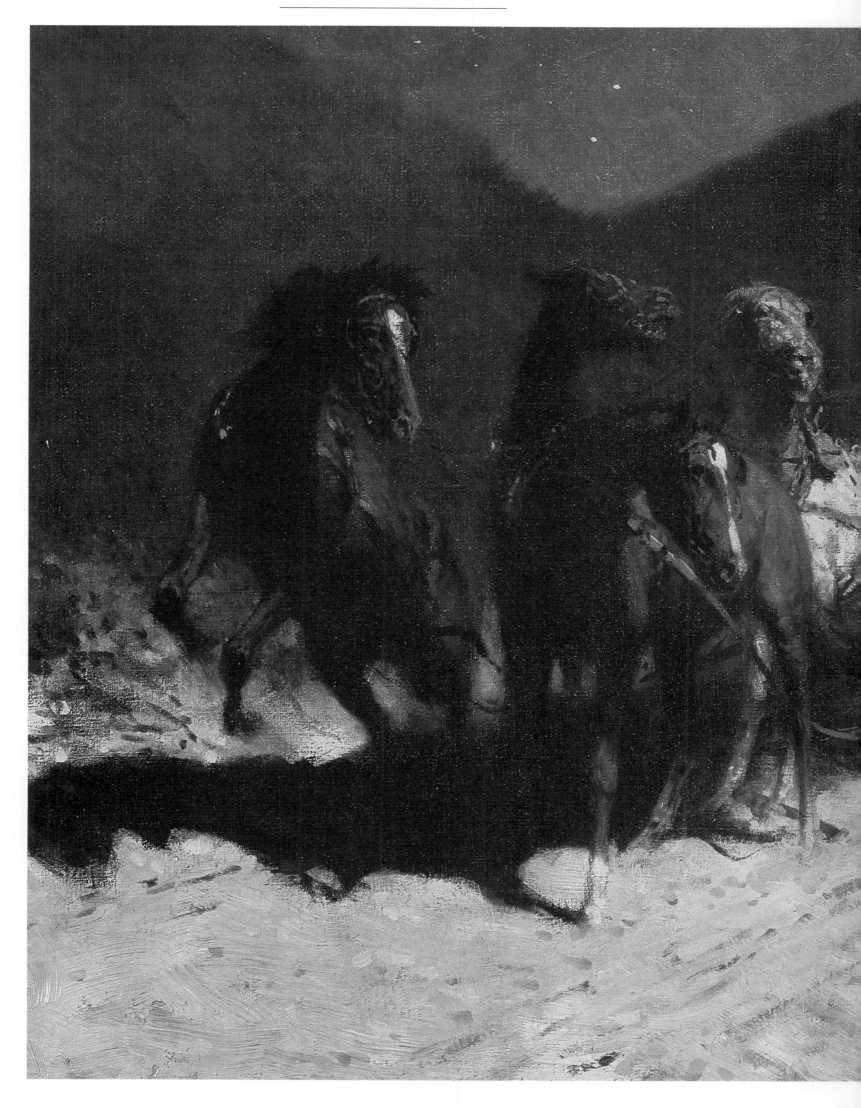

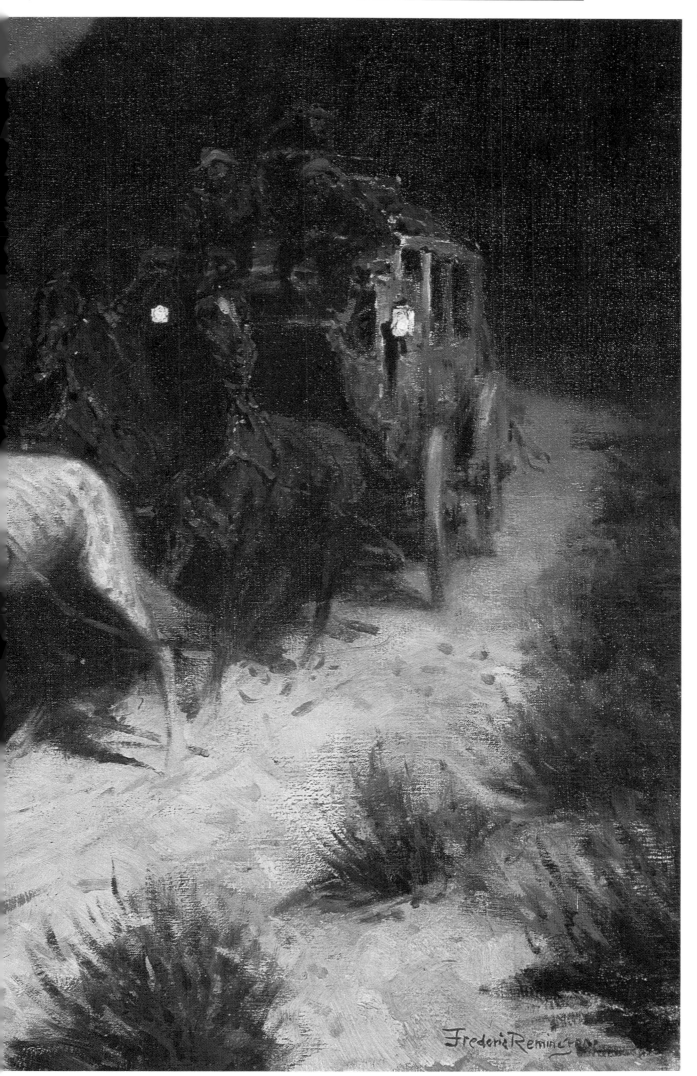

A Taint in the Wind
1906, oil on canvas,
27⅛×40 in.
Sid Richardson Collection of
Western Art, Fort Worth, TX

61

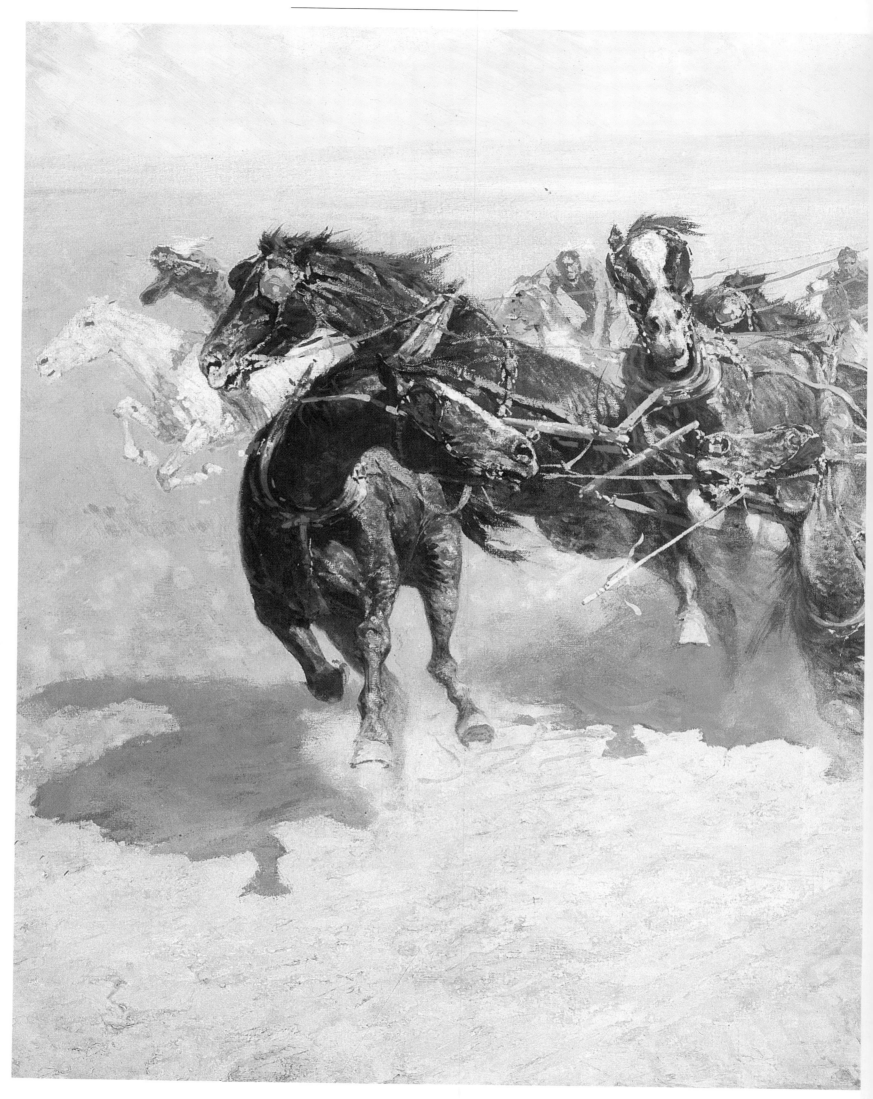

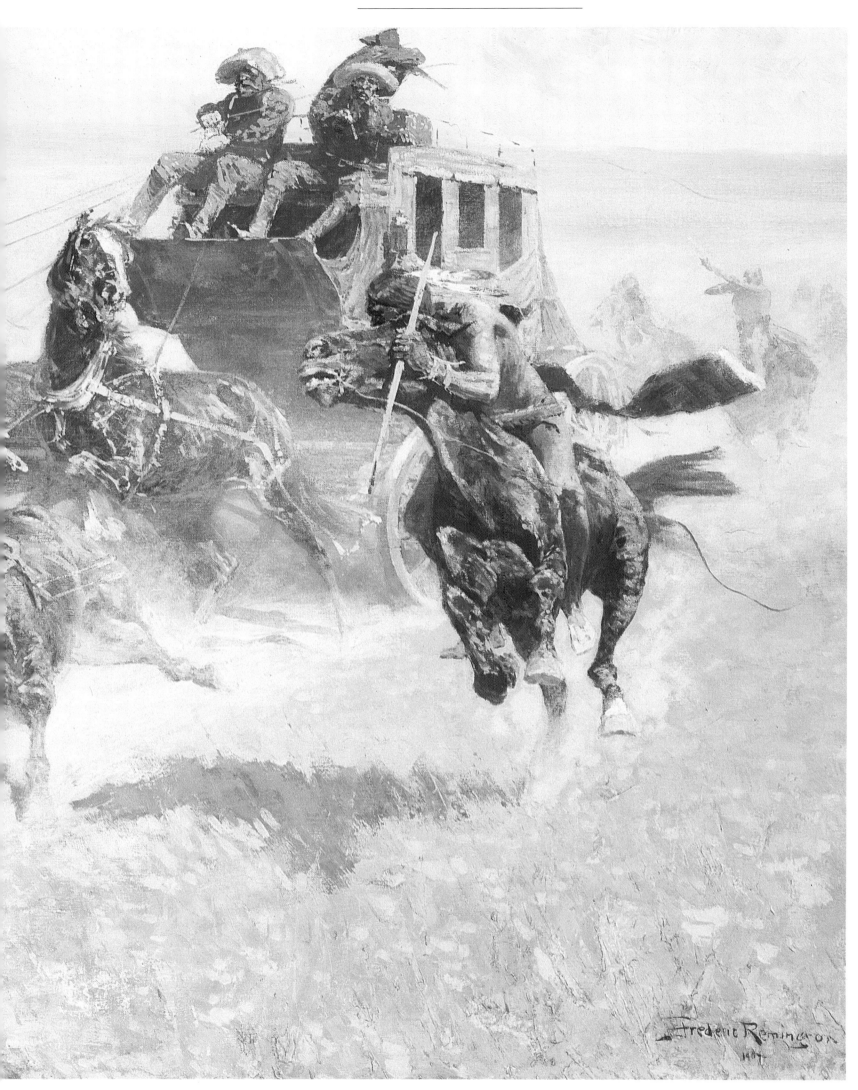

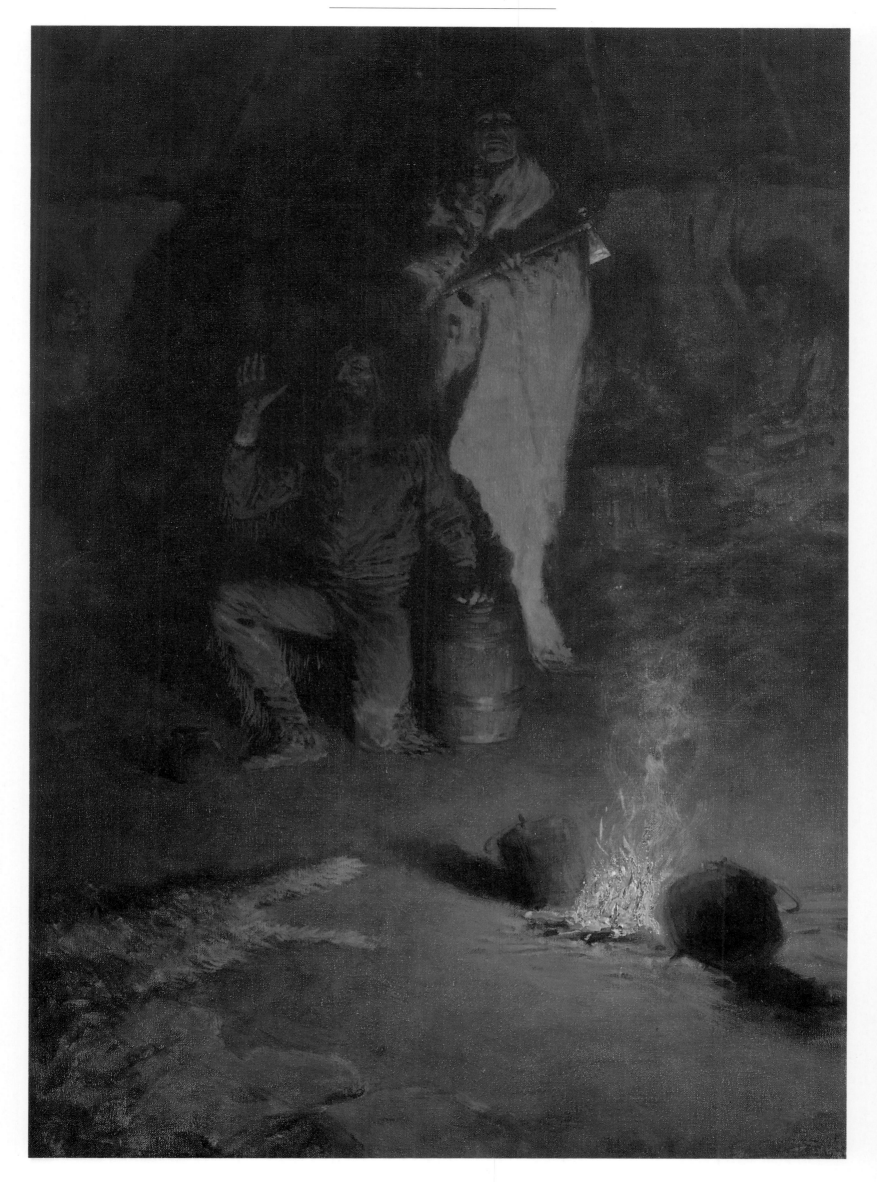

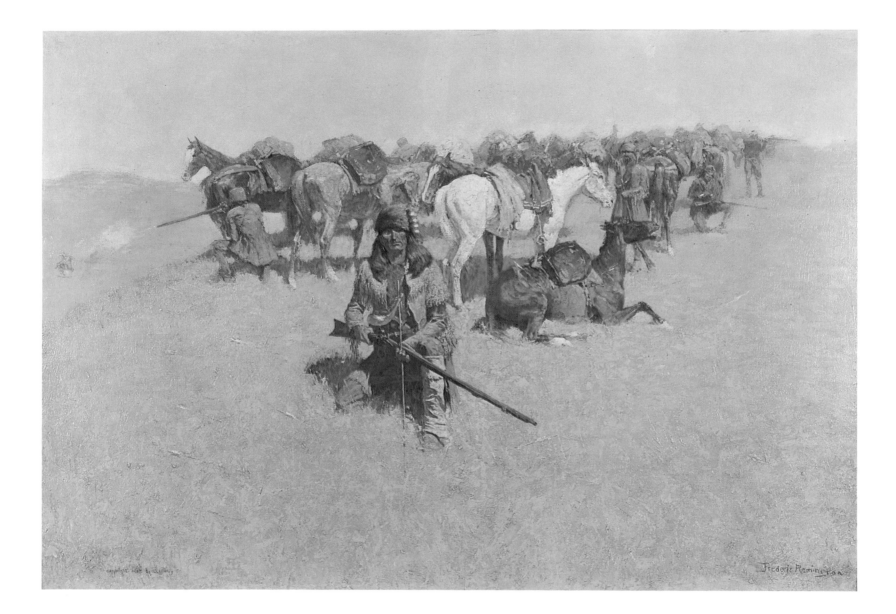

Guard of the Whiskey Trader
1906, oil on canvas, 30¾×21⅛ in.
Gift of Mr. and Mrs. Samuel L. Kingan,
University of Arizona Museum of Art, Tucson, AR

An Old Time Plains Fight
1904, oil on canvas, 27×40 in.
Frederic Remington Art Museum, Ogdensburg, NY

INDIANS

The Indians were a constant source of fascination for Remington. Their exotic tribal customs and their prowess as warriors epitomized for him the romance and mystery of the Wild West. Public opinion regarding the Indians varied. The army's attitude was that "the only good Indian is a dead Indian"; the pioneer considered the acquisition of land as a priority no matter the cost to the Indians; the eastern philanthropist expressed concern to make amends for some of the grievous wrongs that the "red man" had suffered.

Remington's opinion of the Indians was also ambivalent. On one hand he identified with the soldier's patriotic zeal and would often refer to Native Americans as "savages" or "brutes." From this position he saw the Indian in a single dimension – as a ferocious animal – the type he described in an article about the Sioux outbreak in South Dakota:

> I sat near the fire and looked intently at one human brute opposite. He was a perfect animal so far as I could see. Never was there a face so replete with human depravity, stolid, ferocious, arrogant, and all the rest . . . ghost shirt, war paint, feathers and armed to the teeth. As a picture, perfect; as a reality, horrible.

Yet on the other hand, he had a subtle appreciation for the Indians' "mysterious" way of life and thought that it was "against nature" to try and civilize them according to white men's ways. He described an evening scene on an Apache reservation in Arizona in quite another light:

> Presently, as though to complete the strangeness of the situation, the measured 'thump, thump, thump' of the tom-tom came from the vicinity of a fire some short distance away . . . We grew in sympathy with the strange concert, and sat down some short distance off, and listened for hours. It was more enjoyable in its way than any trained chorus I have ever heard.

Remington's knowledge and understanding of the Indians was far greater than that of most white men of his day, and he did have a reputation for portraying Indians without prejudice. From his earliest sketches to his latest moonlight nocturnals, he produced a magnificent record of different Indian tribes on the war path, on reservations and on hunting trails. His earlier work tended to focus on hunting and warring Indians, such as his first prize-winning painting, *Return of a Blackfoot War Party*. His later work more sensitively portrays the mood of the Indian people, from the melancholy *Twilight of the Indian* to the bewitching *Apache Medicine Song*. As Owen Wister wrote:

> He has pictured the red man as no one else has pictured him. He has told his tragedy completely. He has made us see at every stage this race which our conquering race has dispossessed, beginning with its primeval grandeur, and ending with its squalid degeneration under the influence of our civilized manners.

The Outlier
1909, oil on canvas, 40⅛ × 27¼ in.
Bequest of Miss Charlotte Stillman,
The Brooklyn Museum, Brooklyn, NY

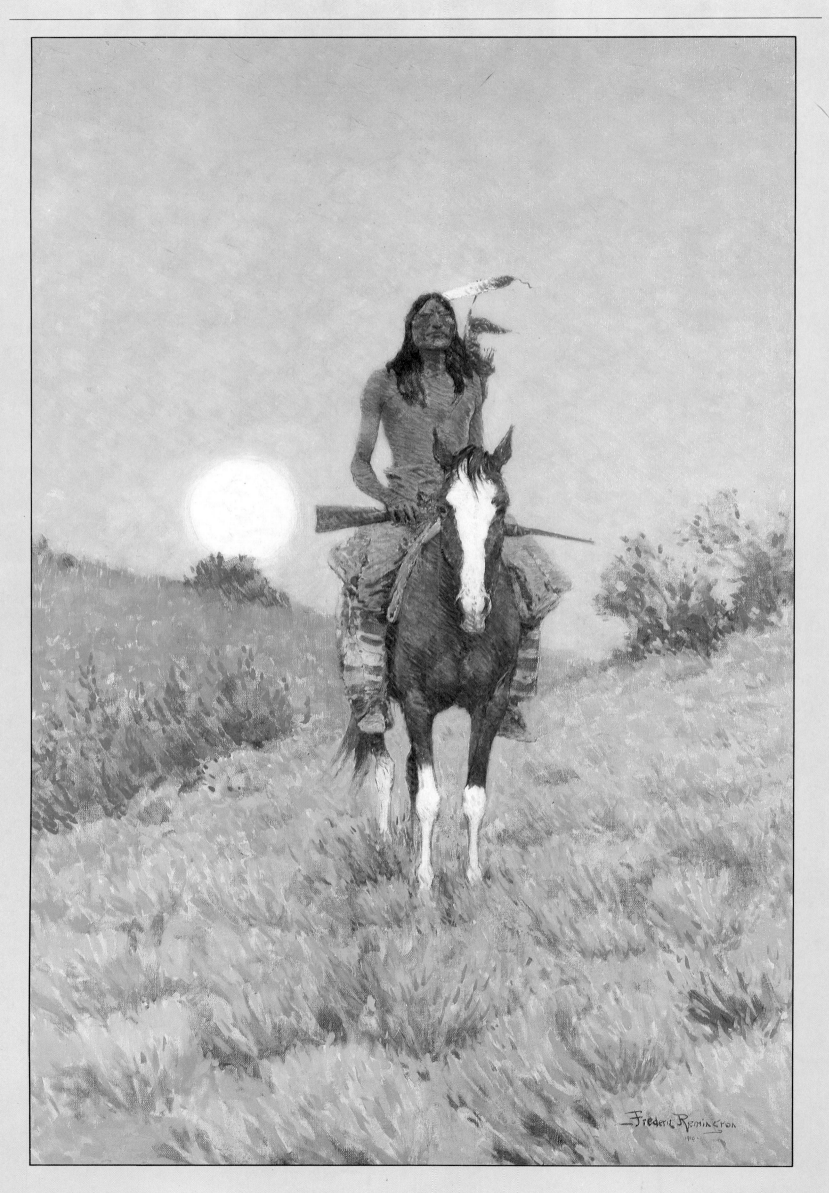

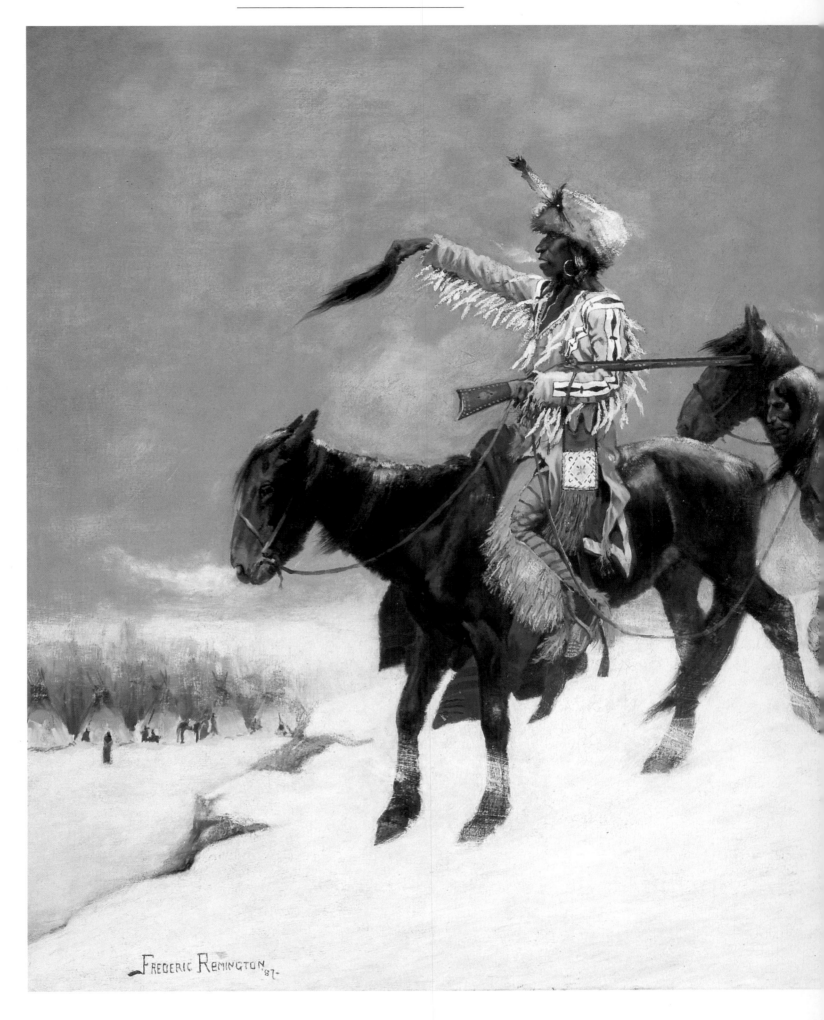

Return of the Blackfoot War Party
1887, oil on canvas, 28×50 in.
The Anschutz Collection, Denver, CO

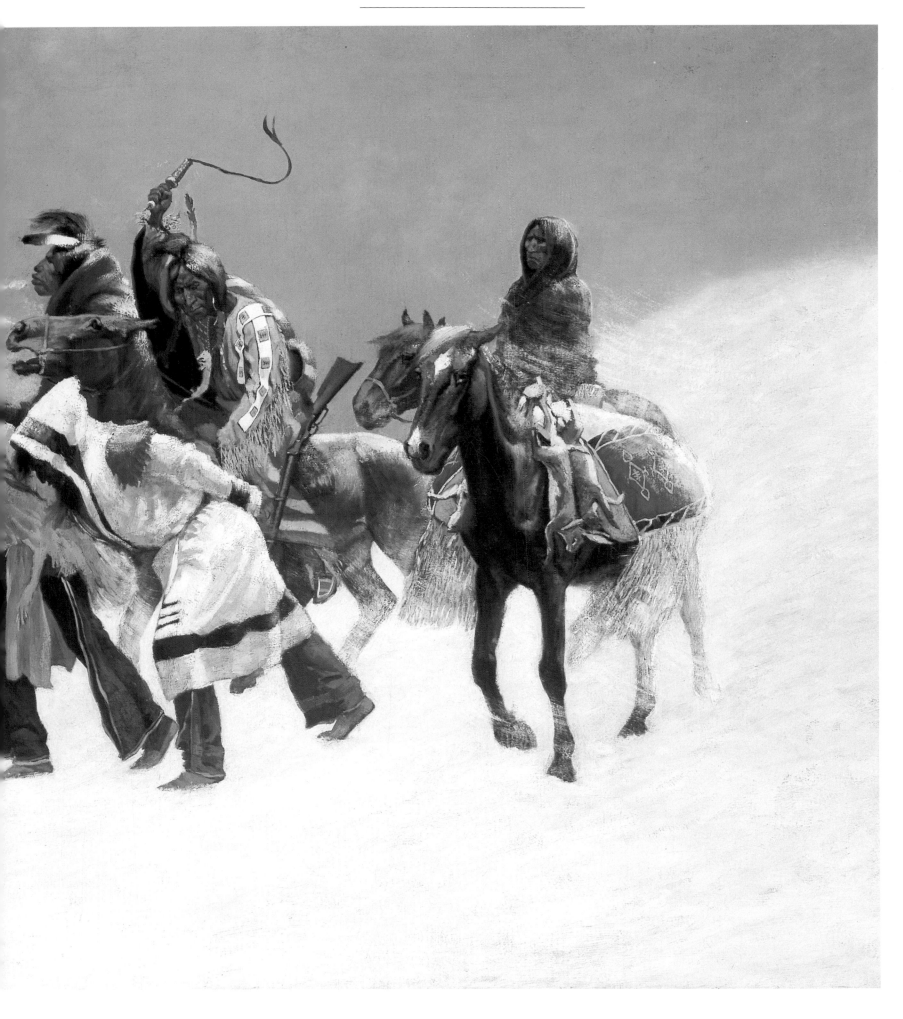

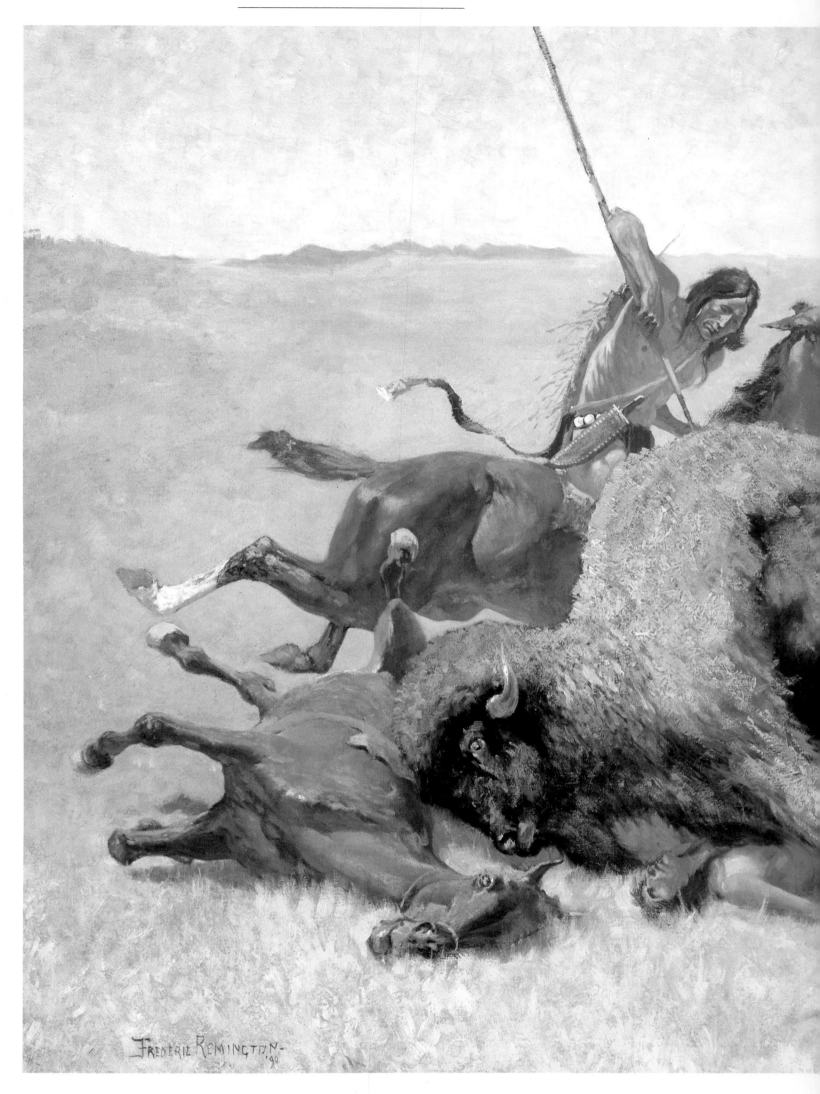

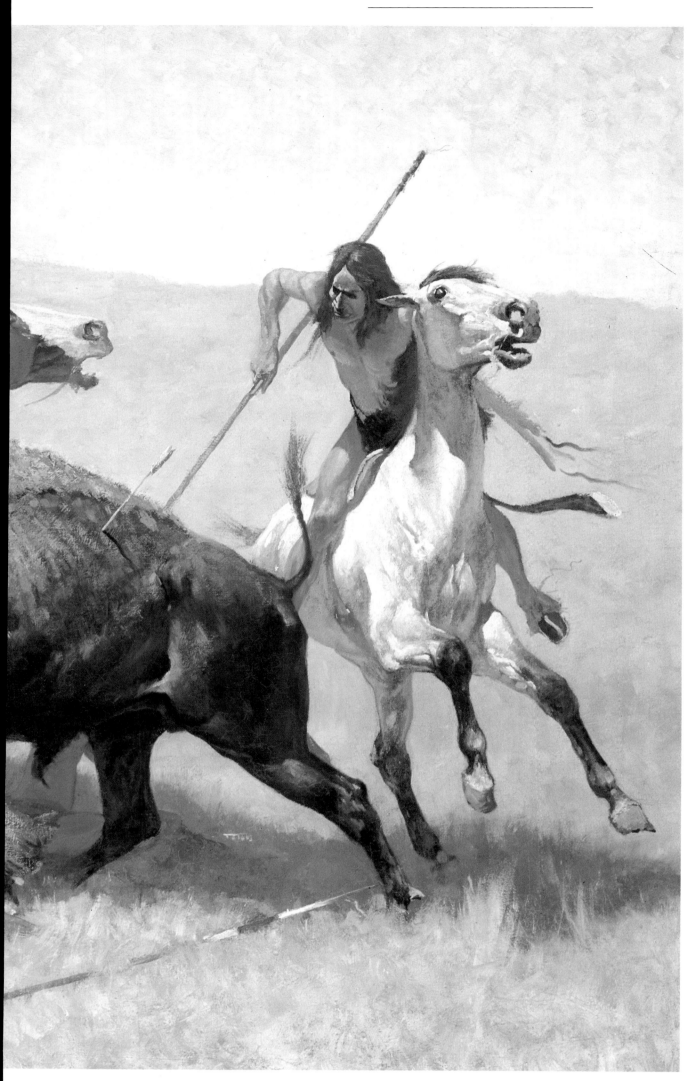

The Buffalo Hunt
1890, oil on canvas,
34×49 in.
*Buffalo Bill Historical Center,
Cody, WY*

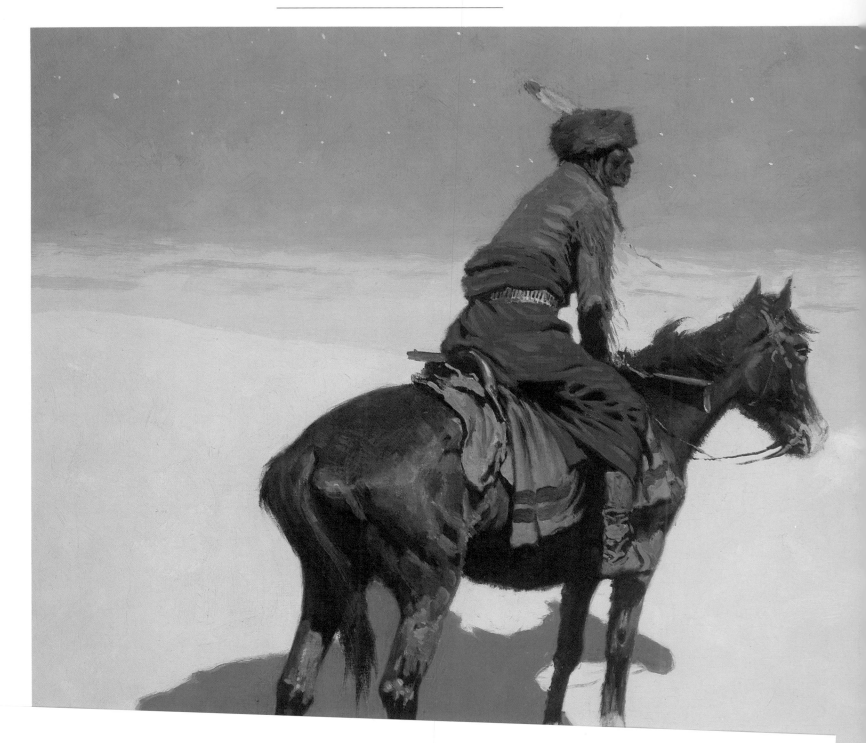

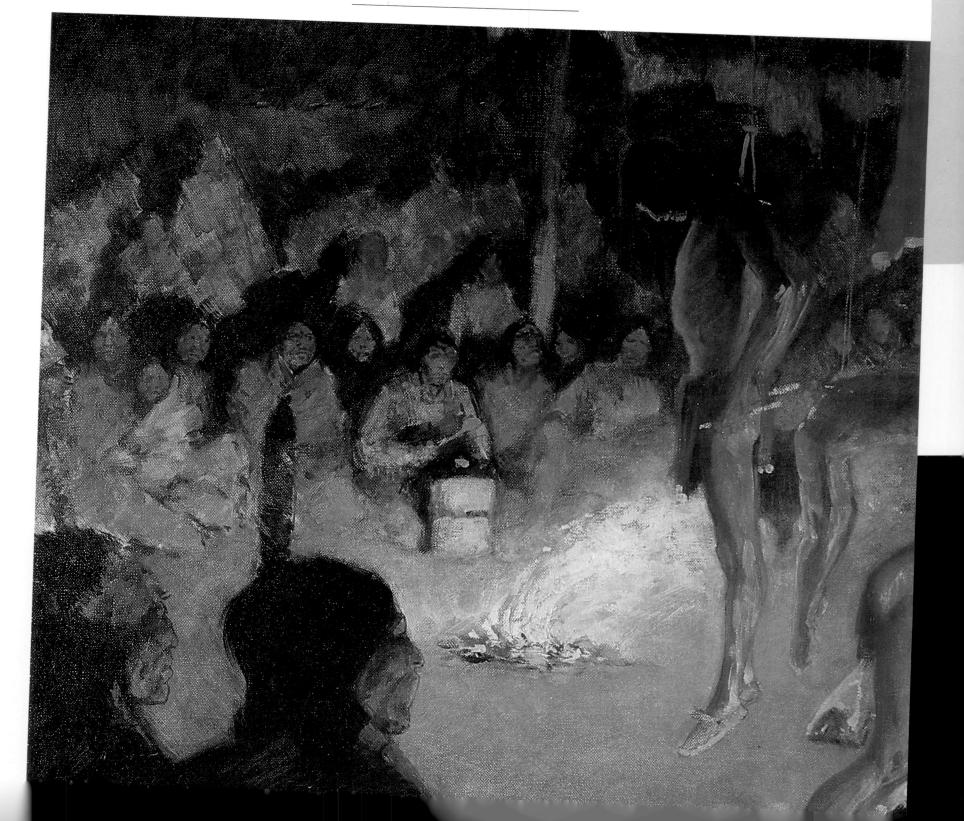

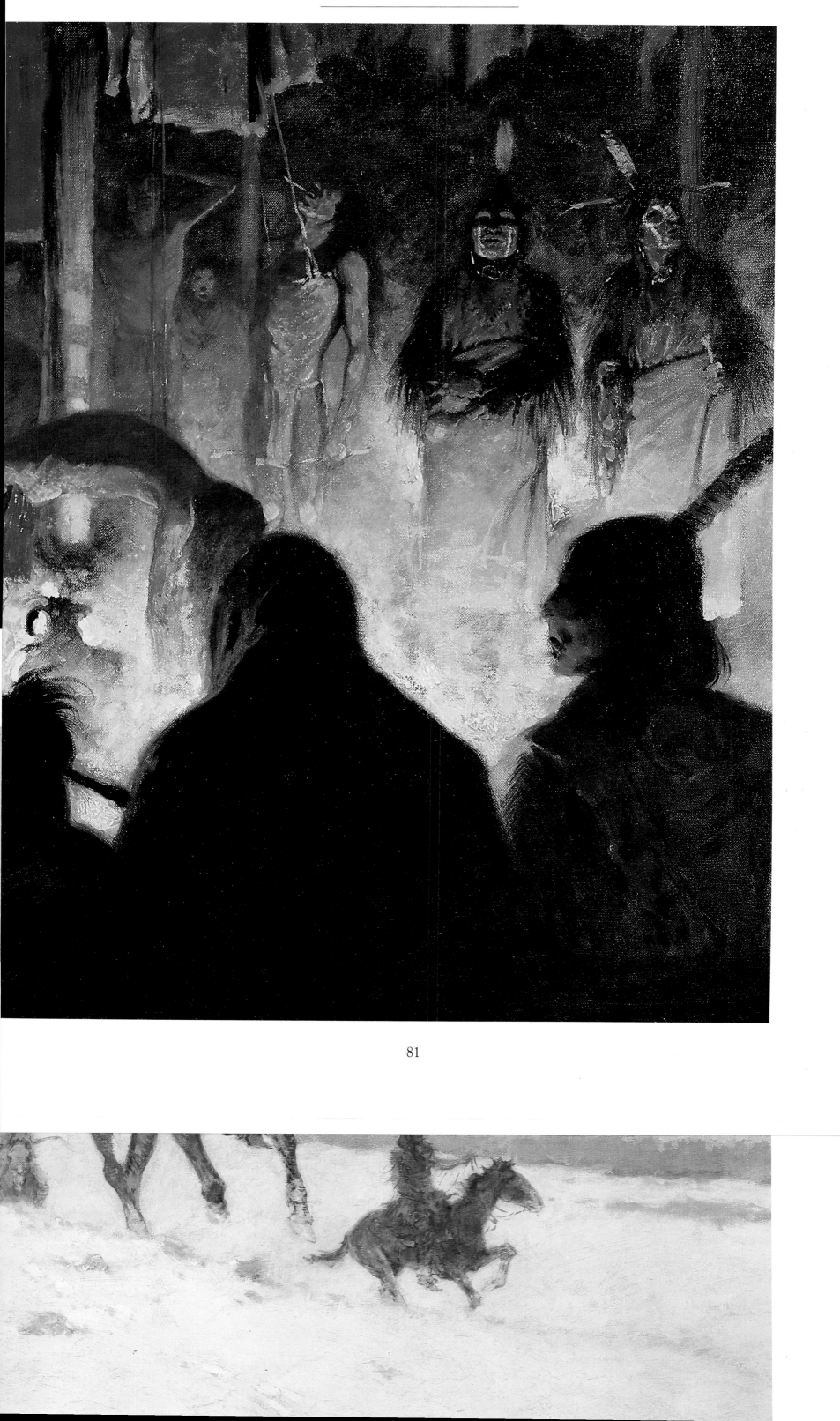

The Snow Trail
1908, oil on canvas, 27×40 in.
Frederic Remington Art Museum, Ogdensburg, NY

Pages 86-87:
The Grass Fire
1908, oil on canvas, 27⅛×40⅛ in.
Amon Carter Museum, Fort Worth, TX

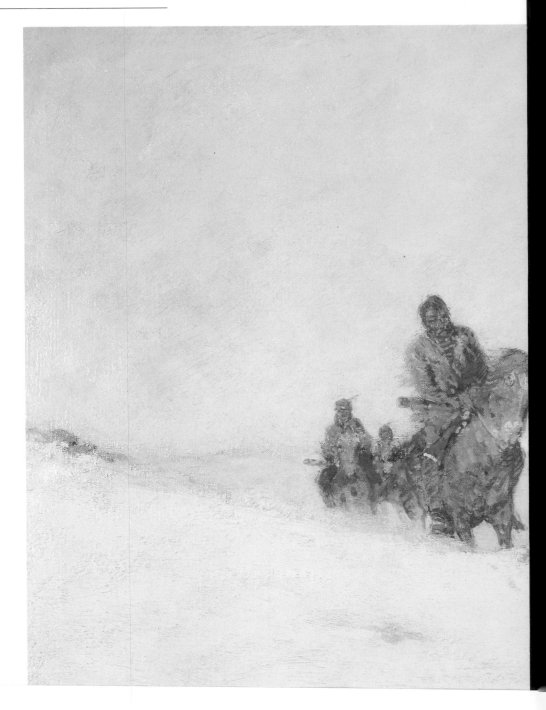

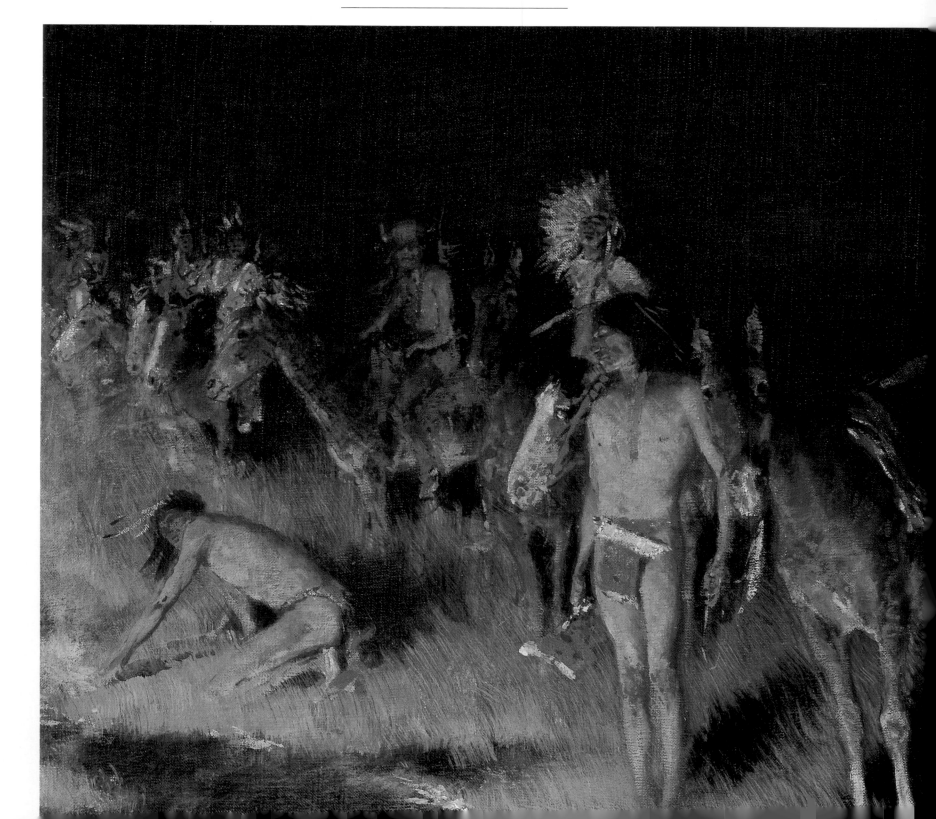

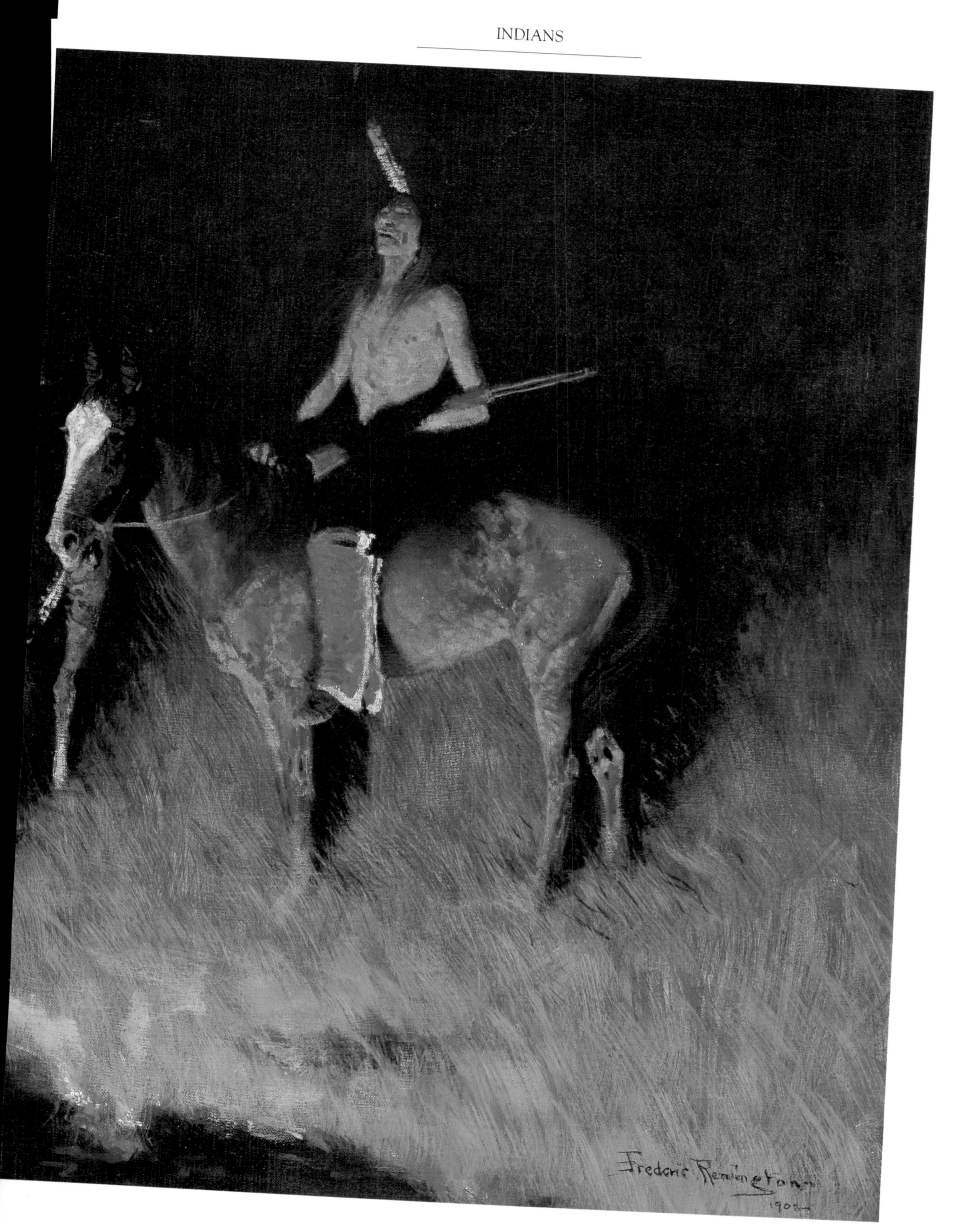

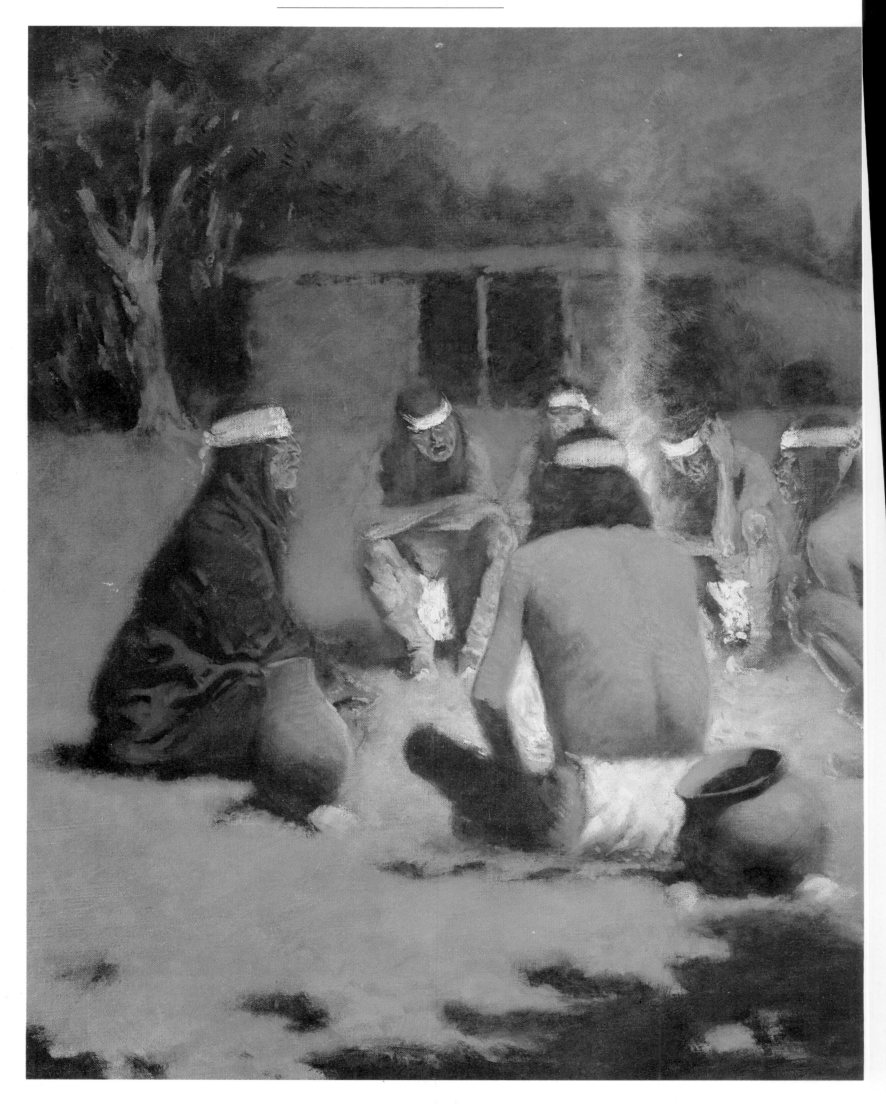

Apache Medicine Song
1908, oil on canvas, 27⅛×29⅞ in.
Sid Richardson Collection of Western Art, Fort Worth, TX

Pages 94-95:
The Smoke Signal
1909, oil on canvas, 30½×48½ in.
Amon Carter Museum, Fort Worth, TX

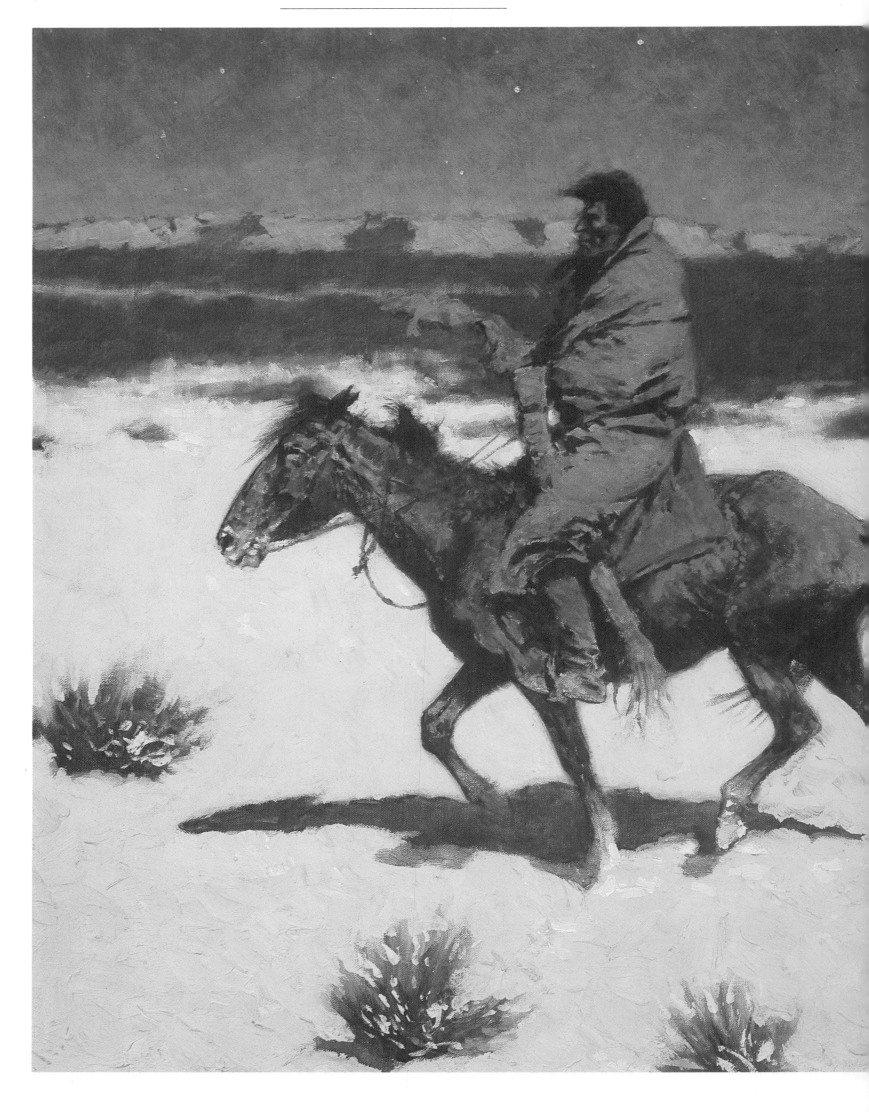

The Luckless Hunter
1909, oil on canvas, 28⅞×28⅞ in.
Sid Richardson Collection of Western Art, Fort Worth, TX

SCULPTURES

Through his sculpture Frederic Remington first gained acceptance as a fine artist. One day his friend Augustus Thomas was watching him at work in his studio and saw him draw a barroom scene, then rub a figure out and draw it completely in reverse. Thomas said to him: "Fred you're not a draftsman, you're a sculptor. You saw all round that fellow, and could have put him anywhere you wanted him. They call that the sculptor's degree of vision." This perceptive remark set Remington thinking.

Later that year in the summer of 1895 the noted sculptor Frederic W. Ruckstull was in Remington's neighborhood, working on a model of his heroic equestrian statue of Brigadier General John Hartfranft, which now stands on Capital Hill in Harrisburg, Pennsylvania. Remington especially admired the horse and asked Ruckstull for some advice about sculpting. Ruckstull gave Remington little more than rudimentary suggestions; nonetheless, by that fall Remington produced his first bronze, *Broncho Buster*, a highly ambitious first project. Remington was a natural sculptor, as he said after completing this bronze in the fall of 1985:

> I propose to do some more . . . to put the wild life of the West into something that burglar won't have, moth eat, or time blacken. It is a great art and satisfying to me, for my whole feeling is for form.

Remington's mastery of three-dimensional form was confirmed by noted critics such as Arthur Hoeber who wrote: "He has handled his clay in a masterly way, with great freedom and certainty of touch, and in a manner to call forth the surprise and admiration not only of his fellow craftsmen, but of sculptors as well. Mr. Remington has struck his gait."

Remington completed several more bronzes over the next few years, all of which received acclaim. In 1901 he adopted an advanced casting technique called "cire perdue," which enabled him to further refine his sculpture. His previous clay models had been cast in bronze by Henry-Bonnard, by which the "sand" method, common to most American foundries, was used. The "cire perdue," or lost wax, casting technique was brought to this country by Riccardo Bertelli. He set up the Roman Bronze Works, where Remington cast his later bronzes. By this technique he was able to preserve the intricate detail, spontaneity and freedom of movement of the original clay model, even to the point of making last-minute changes before casting. He worked closely with Bertelli and often spent days on end at the foundry, in particular when he cast his most famous and challenging piece *Coming Through the Rye*.

In working with clay, Remington was an exacting craftsman who never compromised his vision. His sculpture is remarkable for its realistic renditions of western equestrian figures, which bring to life a bygone era. "That is the fundamental difference," explained Bertelli, "between Remington's work and the statuary of those who have given more consideration to art than realism."

The Broncho Buster
1895, bronze, 23¼ in. high
Amon Carter Museum, Fort Worth, TX

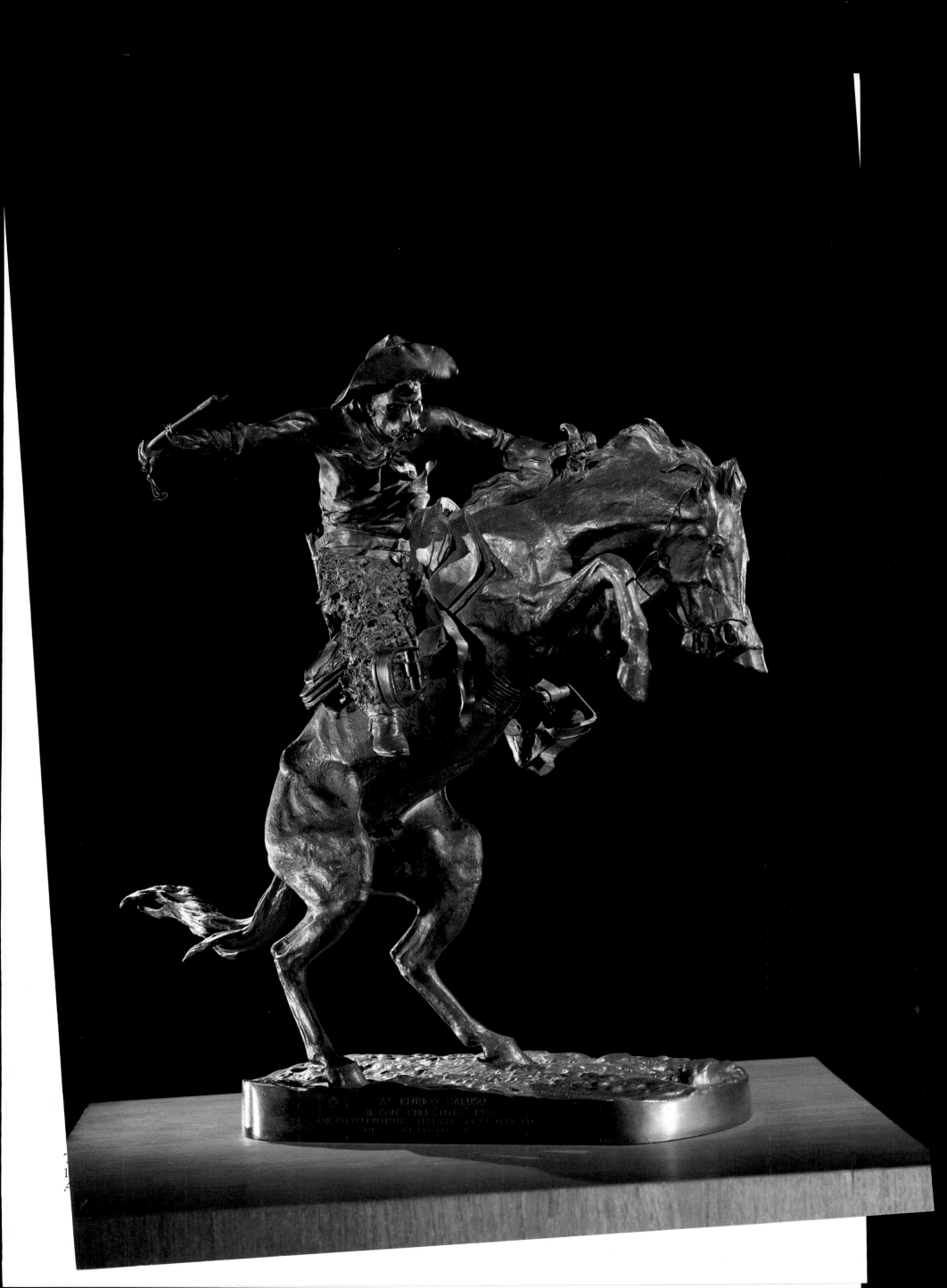

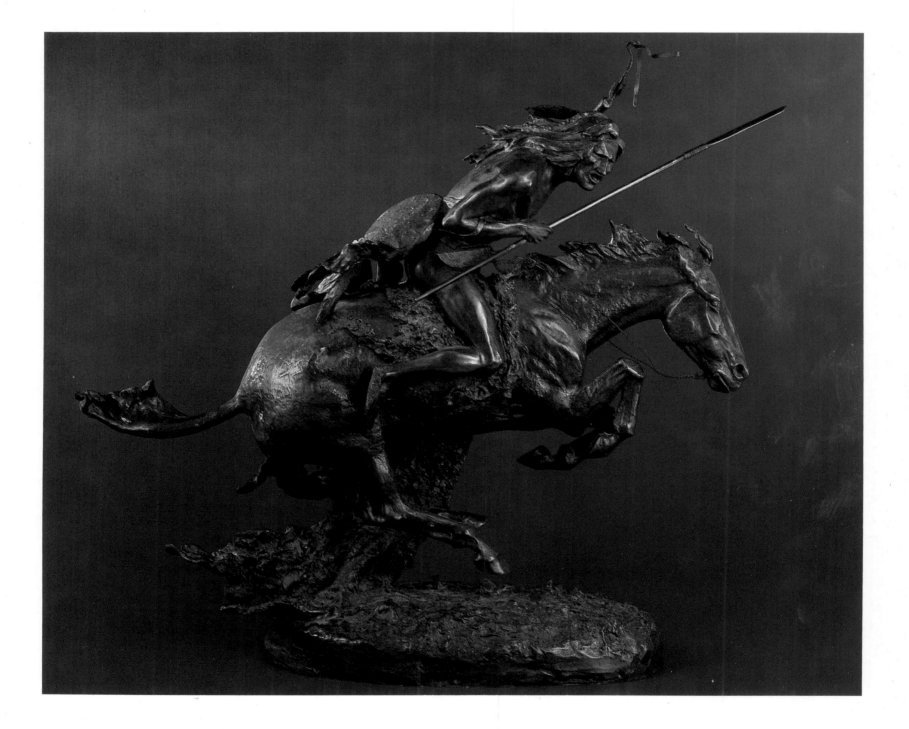

The Cheyenne
1902, bronze, 20⅛ in. high
Buffalo Bill Historical Center, Cody, WY

The Mountain Man
1903, bronze, 28 in. high
Buffalo Bill Historical Center, Cody, WY

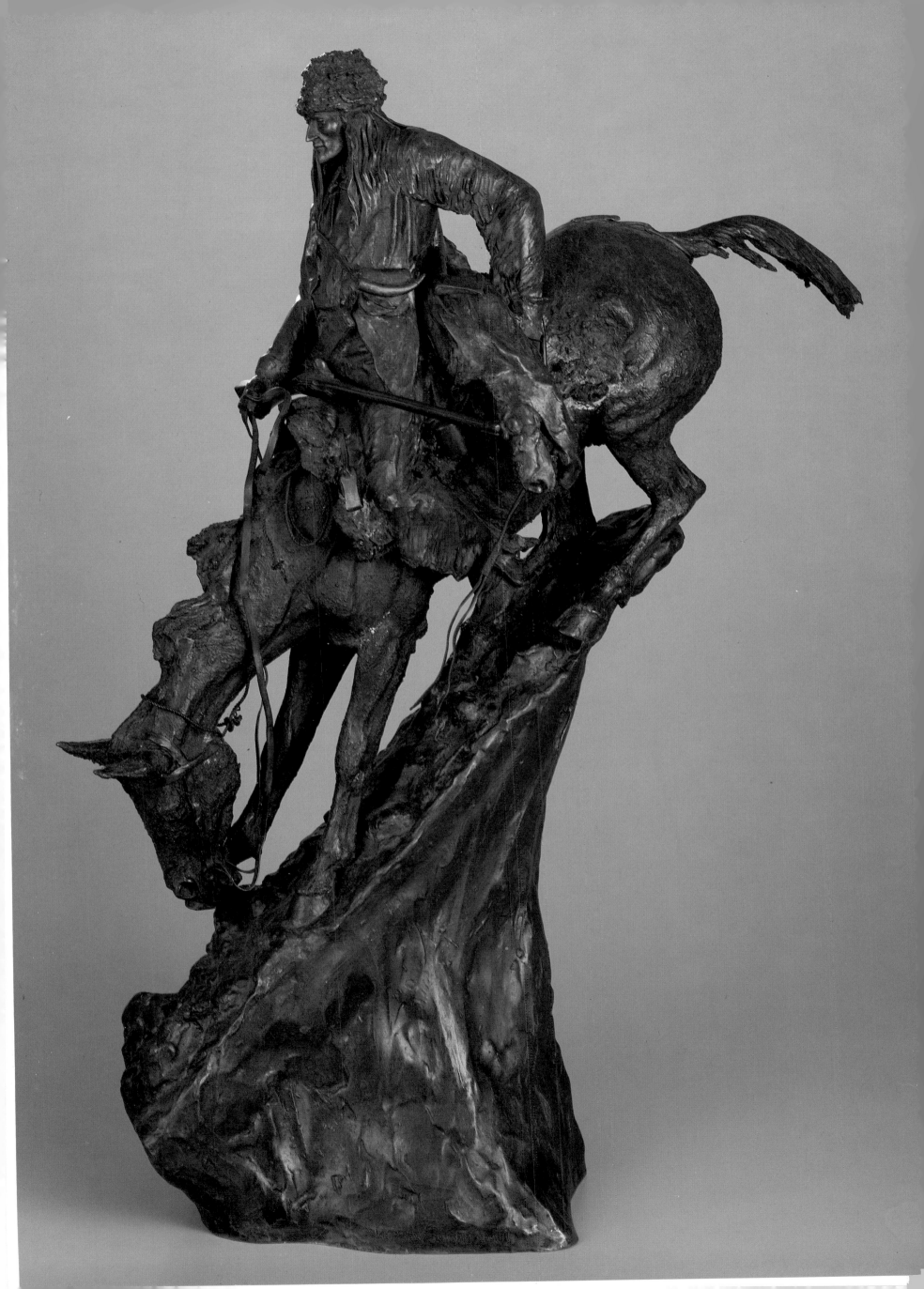

The Savage
1908, bronze, 11¼ in. high
*Frederic Remington Art
Museum, Ogdensburg, NY*

The Stampede
1910, bronze, 23×48×20 in.
*Frederic Remington Art
Museum, Ogdensburg, NY*

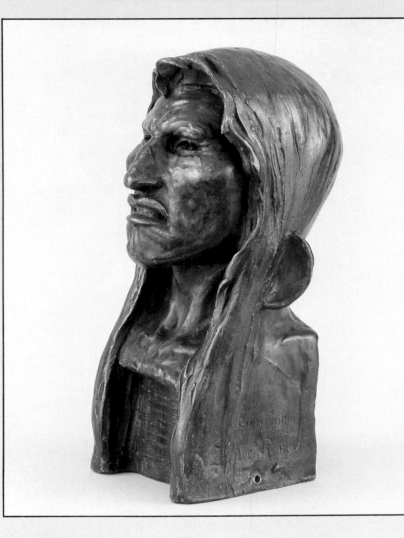

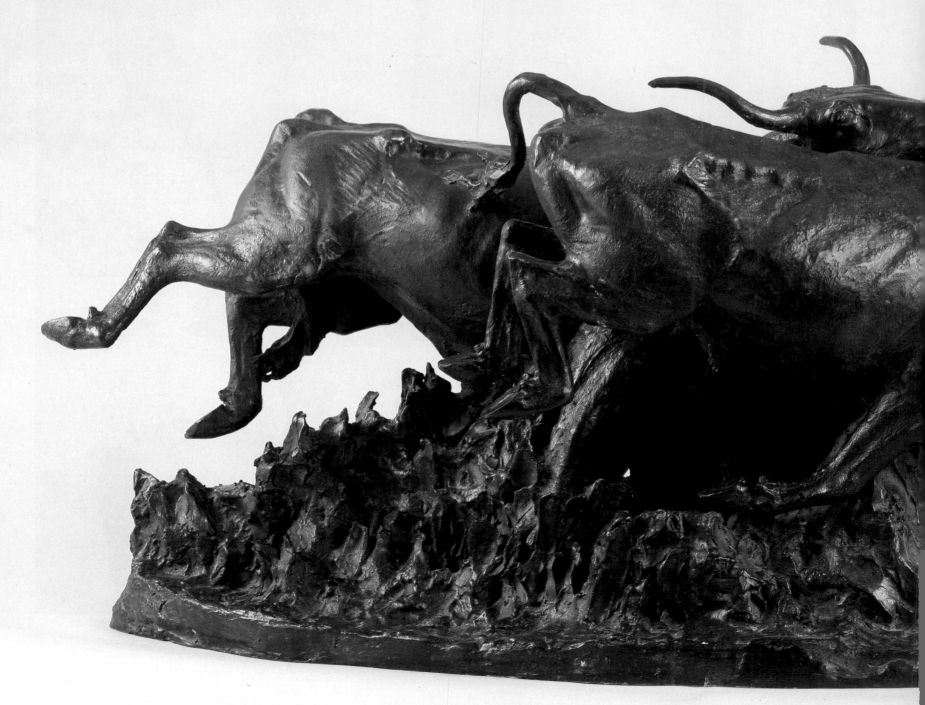

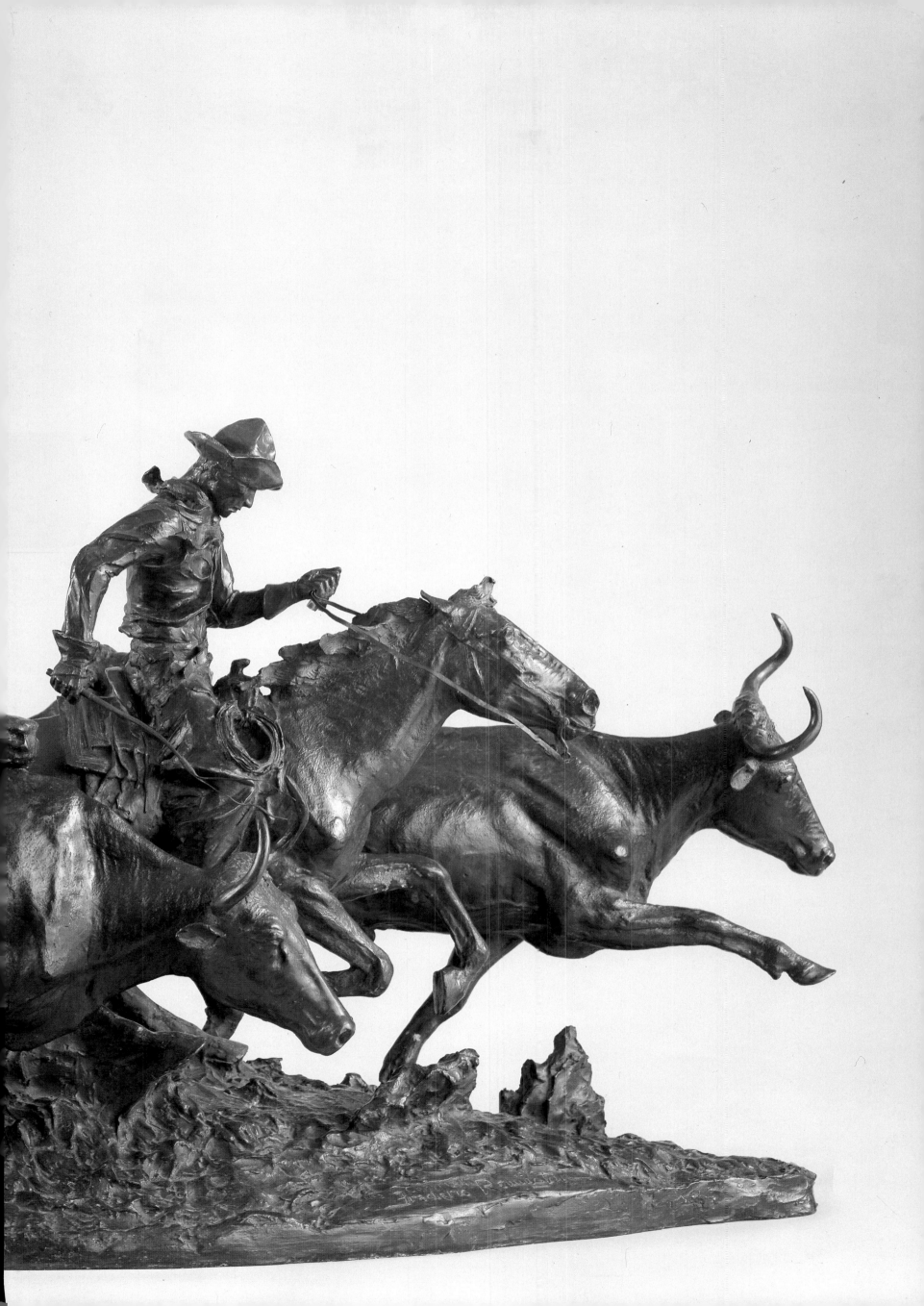

LIST OF COLOR PLATES

Picture Credits

All pictures were provided by the credited museum or gallery except those supplied by the following:
Amon Carter Museum, Fort Worth, TX: 13(middle right)
The Bettmann Archive: 11(bottom)
Brown University Library, Anne S.K. Brown Military Collection: 10(below)
Frederic Remington Art Museum, Ogdensburg, NY: 1, 8(above right), 9(below), 10(above), 11(middle), 12(above and below), 13(middle left), 14(above right)
Kansas City Public Library, Missouri Valley Special Collection: 9(above)
Kingston-upon-Thames Museum and Art Gallery, Eadweard Muybridge Collection: 13(top)

The Library of Congress: 14(above left), 15(below)
National Archives: 6, 11(top), 15(above)
The New York Public Library: 8(below)
The R. W. Norton Art Gallery, Shreveport, LA: 7(below left and right), 14(below)
The C. M. Russell Museum, Great Falls, MT: 13(bottom)
Smithsonian Institution: 7(top)
Yale University: 8(above left)

Acknowledgments

The publisher would like to thank Janet Wu York, who edited and did the picture research for this book; and Mike Rose, who designed it.